IMAGES
of America

ATLANTA SCENES

PHOTOJOURNALISM IN THE ATLANTA
HISTORY CENTER COLLECTION

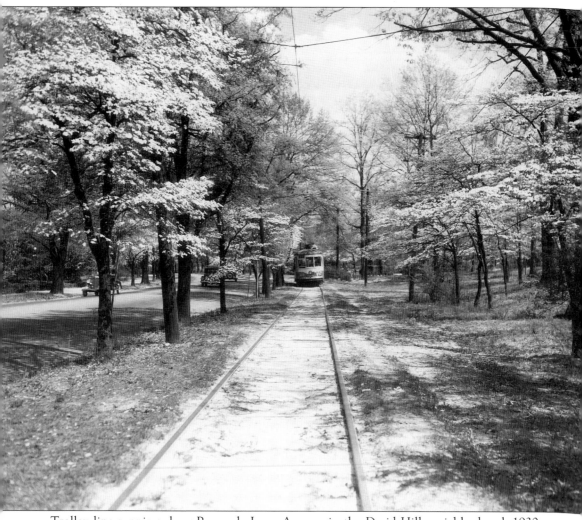

Trolley line running along Ponce de Leon Avenue in the Druid Hills neighborhood, 1930s. (Photograph by Kenneth Rogers.)

IMAGES
of America

ATLANTA SCENES
PHOTOJOURNALISM IN THE ATLANTA
HISTORY CENTER COLLECTION

Kimberly S. Blass and Michael Rose
Atlanta History Center

ARCADIA
PUBLISHING

Copyright © 1998 by the Atlanta History Center
ISBN 978-0-7385-1549-6

Published by Arcadia Publishing
Charleston SC, Chicago IL, Portsmouth NH, San Francisco CA

Printed in the United States of America

For all general information contact Arcadia Publishing at:
Telephone 843-853-2070
Fax 843-853-0044
E-Mail sales@arcadiapublishing.com
For customer service and orders:
Toll-Free 1-888-313-2665

Visit us on the Internet at www.arcadiapublishing.com

Atlanta History Center
130 West Paces Ferry Road
Atlanta, Georgia 30305-1366
(404) 814-4000
http://www.atlhist.org

CONTENTS

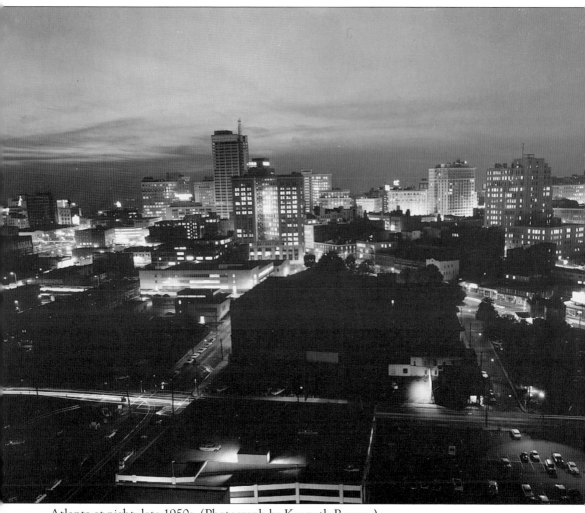

Atlanta at night, late 1950s. (Photograph by Kenneth Rogers.)

INTRODUCTION

Atlanta Scenes: Photojournalism in the Atlanta History Center Collection contains almost 200 images of the Atlanta area, all photographed by some of the city's finest and earliest photojournalists, and all gathered from one place—the visual arts archives of the Atlanta History Center.

Atlanta Scenes is not a narrative history. Rather, it is a selection of images of exceptional quality and composition, chronicling 60 years of the city's noteworthy happenings, personalities, and landmarks. The images range from the everyday—baseball games at Ponce de Leon Ballpark, boys on bicycles, and Humane Society dog rescues—to the eventful—the *Gone With the Wind* premiere, the deadly Winecoff Hotel fire, and the infamous Leo Frank trial. These are scenes of a city at work and scenes of a city at play. Some photos reflect the harsh realities of racism and poverty—a Ku Klux Klan rally and slum housing—and others reflect the traditional images and iconography of the Old South—moss-draped live oaks and antebellum mansions. The subjects of these photos extend north to Georgia's mountains and south to its coast, areas that are often as much a part of an Atlantan's life as the city itself.

This volume is divided into chapters for each of the photojournalists represented—Francis Price, Marion Johnson, Bill Wilson, and Kenneth Rogers, all of whom captured these images while working for the city's two major newspapers, the *Journal* and the *Constitution*. The book's final chapter pulls from a selection of images collected by Rogers during his long newspaper career. Together, these are the photographs that Atlantans saw as they read the front-page news or sipped coffee over their Sunday magazine.

The images in *Atlanta Scenes* do not document all of the important people and events in Atlanta's history. They reflect—for the most part—the people and events the photographers were assigned to cover. Nevertheless, the photographs in this book capture much of Atlanta's history, and convey, as perhaps no other media can, a sense of the time and place they chronicle. *Atlanta Scenes* is not a definitive history of the city, but it still provides the reader with a distinct sense of Atlanta as it evolved from a small Southern city into the capital of the New South.

Kimberly S. Blass
Michael Rose

ACKNOWLEDGMENTS

Atlanta Scenes exists because of the tremendous efforts of the staff and volunteers at the Atlanta History Center. Our utmost appreciation goes to William F. Hull, staff photographer, for his beautiful reproductions of all the images pictured within; without him, this book would not be possible. Very special and well-deserved thanks also go to Arif Khan, for his dedicated assistance with all aspects of this book; Robin Richards, Patrick Dougherty, and Sarah Jane Bruce, library/archives interns, for their research and editorial assistance; Kathy Harmer, library/archives research associate, for her willingness to help with anything and everything; Jackson McQuigg, coordinator of capital projects, for his railroading expertise; and Andy Ambrose, administrator of programs and collections, and Franklin Miller Garrett, historian, for their invaluable knowledge and love of Atlanta's history.

One

FRANCIS PRICE

On December 12, 1909, the *Atlanta Constitution* carried a nondescript photograph of sightseeing cars passing through Atlanta to Florida; its credit line reads, "Francis E. Price." The next day's paper proudly proclaimed the addition of Price as staff photographer, "splendidly equipped" for his position by his many years in the studio business. A photo of a cross-country auto trip was an apt introduction for Price, whose personal exploits—motoring around the state, flying over Atlanta, and hanging from wrecking balls—added an element of risk to his work.

Price was the first full-time staff photographer of an Atlanta newspaper. With the *Atlanta Journal*'s Winn and the *Atlanta Georgian*'s Lane Brothers, he helped to develop the relatively new profession of photojournalism. Over time the photographs provided by Price and other photojournalists helped to sell papers, and room was increasingly devoted to their images.

Born in Anniston, Alabama, in 1886, Price was considered one of the foremost newspaper photographers in the South, evidenced by his groundbreaking work as an aerial photographer and his coverage of the Great Atlanta Fire of 1917. Beleaguered by financial problems and depressed over the death of his father, Price died of an apparent suicide in February 1928.

While much of his work was tragically destroyed in a fire at the *Constitution*'s building, a number of images remain, and his pioneering work left a heritage for his profession.

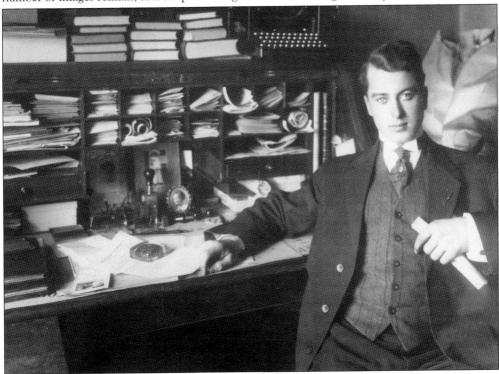

Photographer Francis Price is shown at his roll-top desk in his *Atlanta Constitution* office.

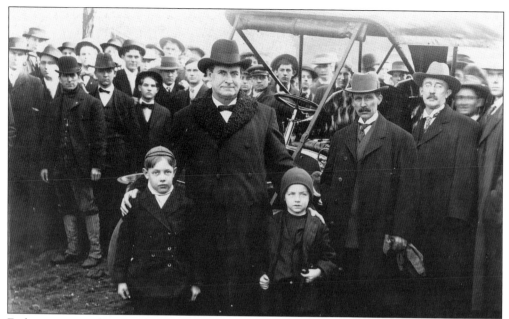

Early newspaper photography centered on portraits of political, business, and social personalities. William Jennings Bryan, three-time Democratic presidential candidate and President Woodrow Wilson's secretary of state, posed for this picture during a visit to Atlanta.

In October 1910, former president Theodore Roosevelt visited Martha Berry at the Berry Schools (now Berry College) near Rome, Georgia. Colonel Roosevelt and Miss Berry stand beside the carriage and mule team, "Nip and Tuck," with which he was shown around the grounds of the school.

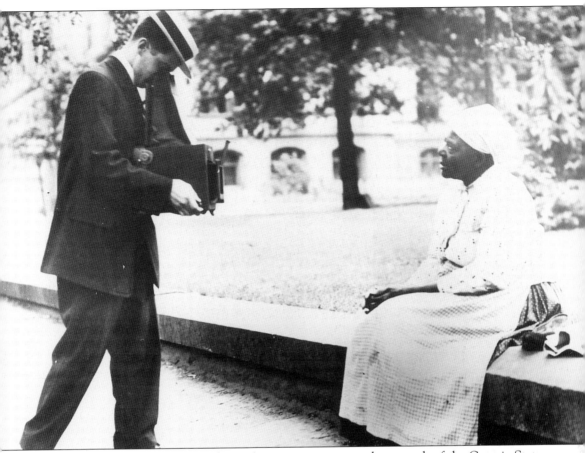

Francis Price photographs an African-American woman on the grounds of the Georgia State Capitol, c. 1915. Price uses a Graflex camera, the standard professional photojournalist's camera during the first 20 years of the century. Price looks through a leather funnel into the viewfinder to focus on his subject. This Graflex used glass-plate negatives.

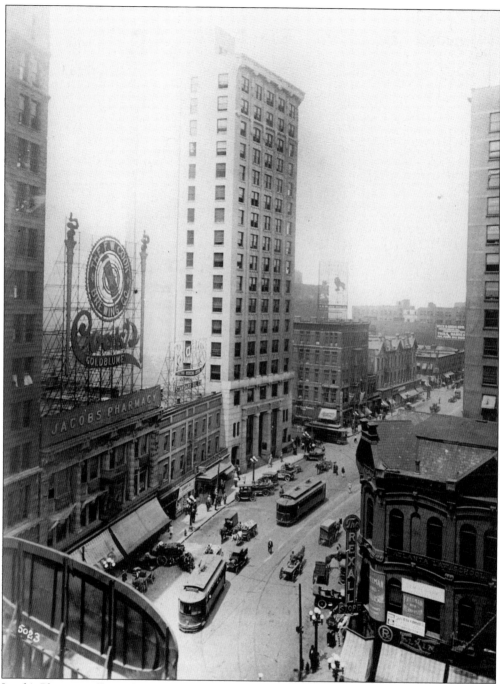

Jacob's Pharmacy (lower left), *c.* 1915, stood on Marietta Street at the northwest corner of Five Points, in the heart of Atlanta's business district. It was here in 1886 that the first sale of Coca-Cola took place at Willis Venable's soda fountain.

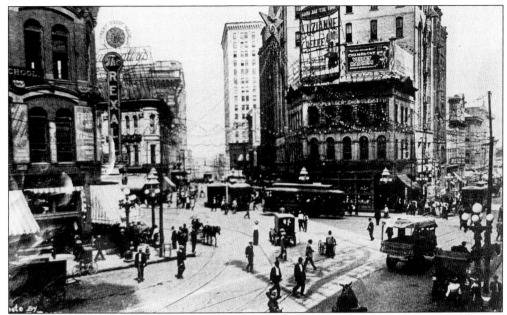

The business and cultural center of early Atlanta was Five Points—the convergence of Peachtree, Edgewood, Decatur, and Marietta Streets in downtown Atlanta. Looking east along Edgewood Avenue, this scene includes street decorations for the Shriners' 1914 national convention.

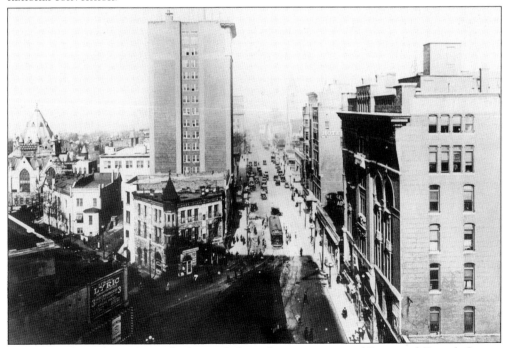

This view of Peachtree Street looks north from the intersection of Pryor and Forsyth Streets (now Margaret Mitchell Square), c. 1915. This scene includes the Winecoff Hotel (left), constructed in 1913, and De Give's Grand Theatre (lower right), later Loew's Grand (and the site of the *Gone With the Wind* premiere).

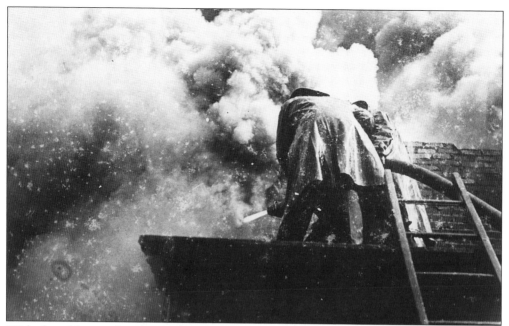

With the addition of professional staff photographers, such as Price, publishers increased the number of action scenes in newspapers. In February 1914, the entire Atlanta Fire Department battled a blaze in the McKenzie Building at Peachtree and Forsyth Streets. Causing an estimated $150,000 damage, the fire burned for a number of hours and drew a Sunday afternoon crowd of 25,000 onlookers. The city's fire department was organized in 1882, but faulty water lines, poor fire code enforcement, and flammable building materials hampered efforts to fight fires in the early years of this century.

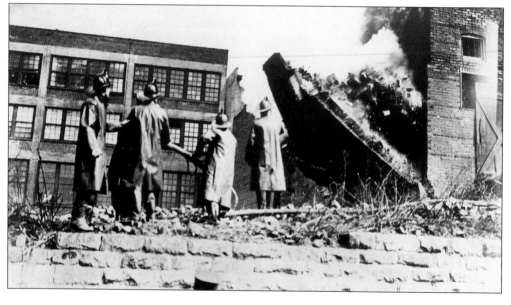

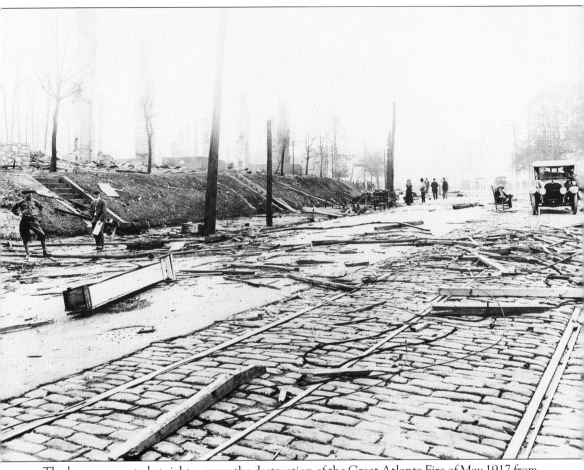

The lone man seated at right surveys the destruction of the Great Atlanta Fire of May 1917 from the comfort of possibly all he has left—his rocking chair. Erupting on the morning of the 21st, the fire burned out of control for nearly 12 hours until a fire break was created by dynamiting dozens of homes along Ponce de Leon Avenue. Nearly 50 city blocks were destroyed at a 1917 cost of more than $5 million. Amazingly, there were no deaths reported in the conflagration.

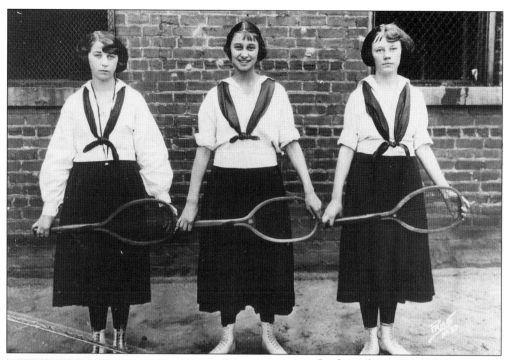

Students from Girls' High pose for publicity shots in 1921. Established with Atlanta's public school system in 1872, Girls' High School continued to operate as the flagship school for young women in Atlanta until its closing in 1947.

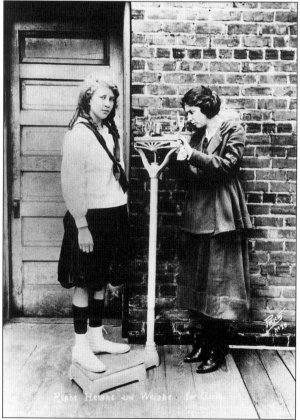

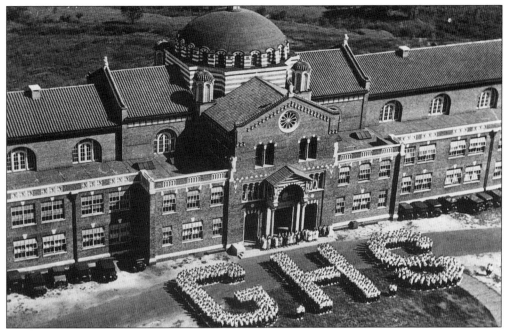

Francis Price was a pioneer of aerial photography, and the newspaper often featured his striking scenes of "Atlanta from the Sky." Frequently, the photographer mounted his equipment in the bottom of the plane and focused through a hole cut in the fuselage. This aerial view of Girls' High near Grant Park was taken in 1927.

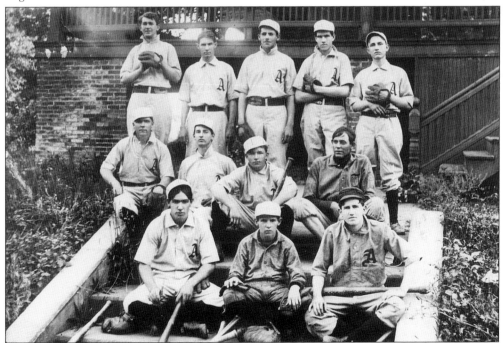

The Atlanta Athletic Club baseball team poses here in 1906. Founded in 1898, the club later assumed responsibility for the East Lake Country Club, which produced famous golfer Bobby Jones.

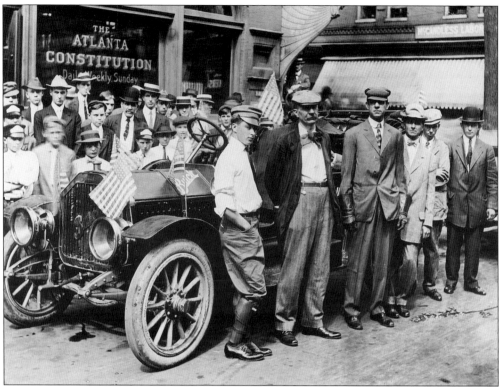

In 1910, the *Atlanta Constitution* sponsored a "Round the State Tour" to campaign for better roads. At the time, two-thirds of Atlanta's streets were unpaved. Above, photographer Francis Price (gentleman with hand in pocket) accompanied a team of reporters to visually document the journey. Ralph Bingham (below), a popular humorist of the day, went "Laughing 'Round Old Georgia" to help publicize the tour.

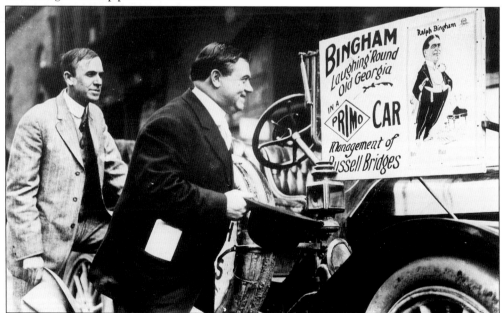

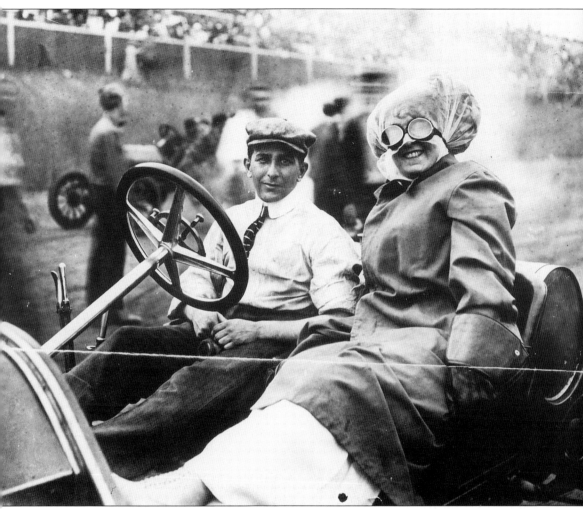

Two participants of the Savannah Races pose here, *c.* 1910. An open-road auto race conducted by the Automobile Club of America, these races were held in Savannah in 1909, 1910, and 1911 as the group's grand prize event.

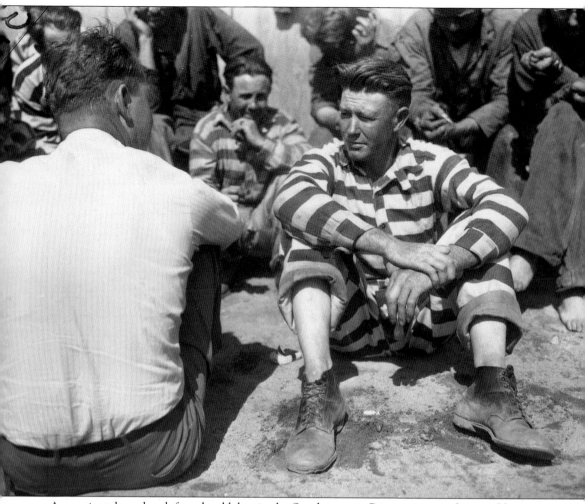

A convict takes a break from hard labor in the Southern sun. Prisoners were often used by state and county governments as cheap labor for road building and other projects, especially in the 1930s and 1940s. (Photograph by Marion Johnson.)

Two

MARION JOHNSON

Born in Geneva, Georgia, in October 1917, Marion Johnson moved to Atlanta in 1936, joining his sister who worked as a secretary for the *Atlanta Constitution*. At her suggestion, Johnson took a job as an office boy for the paper, working in the news department. While there, he was approached by Kenneth Rogers, who encouraged him to learn about photography. Under Rogers's tutelage, Johnson mixed chemicals and studied photography in his spare time. Eventually, he was hired by UPI as a wire photo transmitter, and worked with them from 1938 until 1941 in their Atlanta and Dallas, Texas, offices. Johnson then returned to Atlanta to work on the staff of the *Constitution* and served as a Marine photographer during World War II.

The four photographers featured in *Atlanta Scenes* all succeeded one another at the papers, stretching from Francis Price's hiring by the *Atlanta Constitution* in 1909 to Marion Johnson's placement as head of the *Atlanta Journal-Constitution Magazine* in 1979. For 70 years, this heritage of apprenticeship and training created the legacy of images found here. During that time, incredible advances took place in photojournalism technology. The photographers represented here, including Johnson, were the leaders, award winners, and often-innovative creators, not only of these beautiful and timely photographs, but of the profession as well.

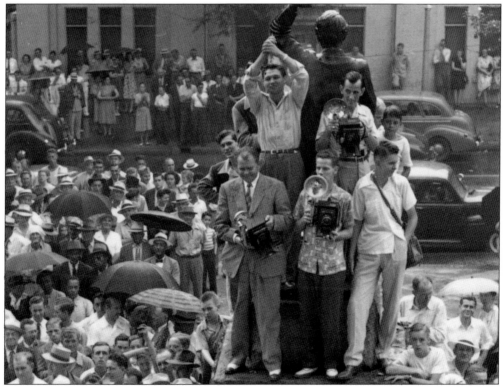

Marion Johnson (photographer at upper right) stands with camera ready during a speech at the Georgia State Capitol. Johnson and other photographers climbed atop the statue of Tom Watson to get a better angle on the speaker. (Detail of image from page 45.)

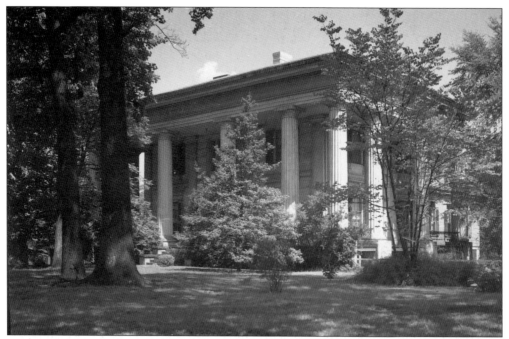

Built in 1842 for Barrington King, son of town founder Roswell King, Barrington Hall still stands in Roswell, just north of Atlanta. Designed in the Greek Revival style, the antebellum residence exemplifies the nation's enduring concept of the romantic Old South, generally symbolized by such "Southern mansions" as Tara in *Gone With the Wind*.

The multistoried steeple of the First Baptist Church, designed by the firm of Stevens and Wilkinson, stands sentinel over Peachtree Street in Midtown Atlanta. Built in 1929, the church is located just north of the Georgian Terrace and Ponce Apartment buildings (far right).

Constructed in 1889, Georgia Tech's Administration Building is the campus's oldest building and a symbol of the university. The Georgia Institute of Technology opened in 1888, with 130 students and one-course offering—mechanical engineering.

A statue of Governor Joseph E. Brown stands on the grounds of the Georgia State Capitol, the city's tallest building at the time of its completion in 1889. Officially chartered as a city in 1847, Atlanta did not become the state's capital until 1877, following Reconstruction.

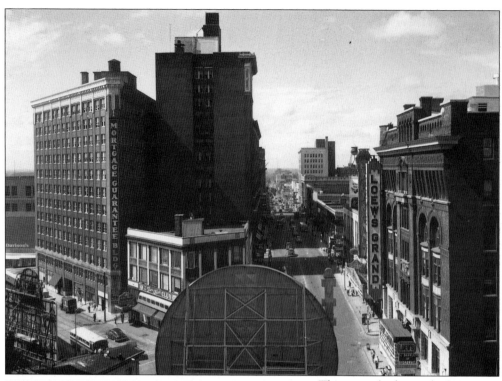

This scene looks north along Peachtree Street from a perspective behind the Coca-Cola sign that stood at present-day Margaret Mitchell Square. Loew's Grand (right), site of the *Gone With the Wind* premiere, was destroyed by fire in 1975.

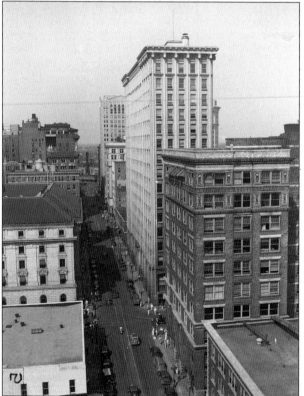

This view looks along Forsyth Street in downtown Atlanta toward Peachtree Street and the Paramount Theatre. Located in what was once the city's primary business district, Forsyth Street is now part of the Fairlie-Poplar Historic District.

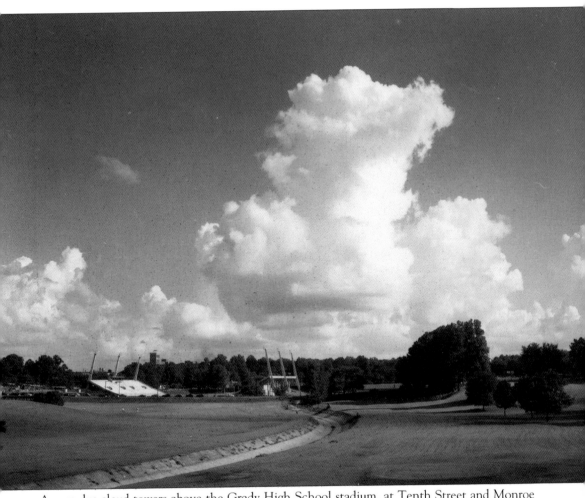

A cumulus cloud towers above the Grady High School stadium, at Tenth Street and Monroe Drive in Midtown Atlanta, as seen from Piedmont Park.

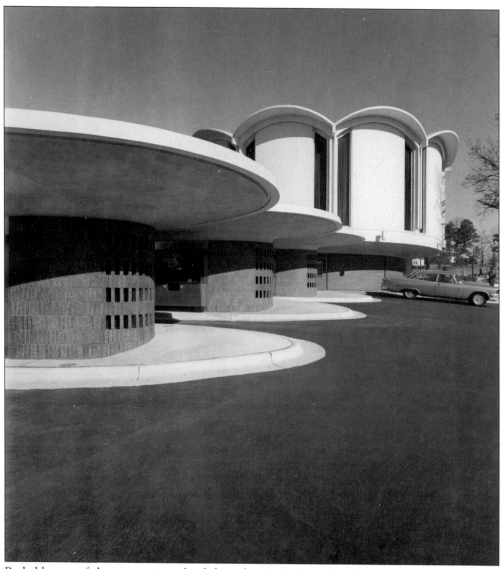

Probably one of the most unique bank branches in Atlanta, the Trust Company Bank (now SunTrust) on Monroe Drive was designed in 1962 by Henri Jova.

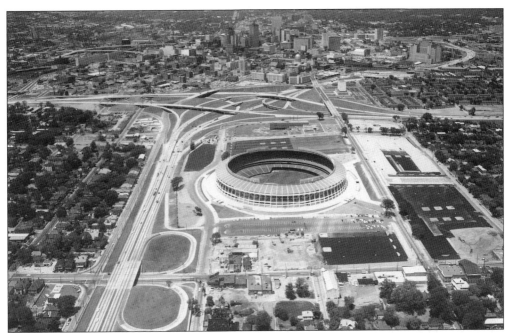

The Atlanta-Fulton County Stadium appears in the foreground of a late-1960s view of the Atlanta skyline. Once home to the Atlanta Braves baseball team, the Atlanta Falcons football team, and the Atlanta Chiefs soccer team, the facility was constructed on an urban renewal site in 1965 and demolished in 1997.

A monolith of Art Deco lines, the Southern Bell Telephone Company Building (now the AT&T Communications Building) at Auburn Avenue and Ivy Street, is shown here, c. 1947. Originally standing only six stories tall, subsequent changes and additions to the building now make this version almost unrecognizable.

On March 2, 1950, children (above) mourned the loss of the Atlanta Zoo's 22-year-old elephant, Coca. Coca was given to the Grant Park zoo in 1933 by Asa G. Candler Jr. (son of The Coca-Cola Company founder), who kept the animal on his Druid Hills estate along with other elephants named Cola, Delicious, and Refreshing. The animal—who developed degenerative arthritis, leaving her unable to walk—had to be put to sleep. Candler

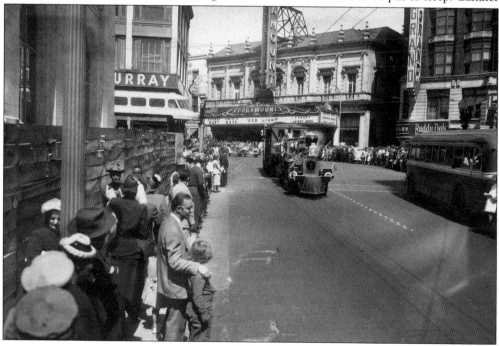

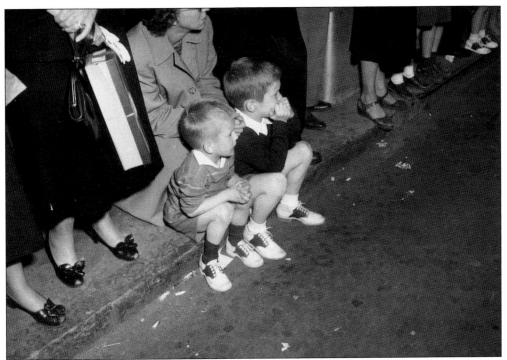

and the Atlanta newspapers launched a campaign to replace the beloved animal, urging schoolchildren to donate "Pennies for Pachyderms." Enough money was raised to purchase two elephants: Penny and Coca II (below). The parade (opposite page, below) was held in honor of the elephants' arrival.

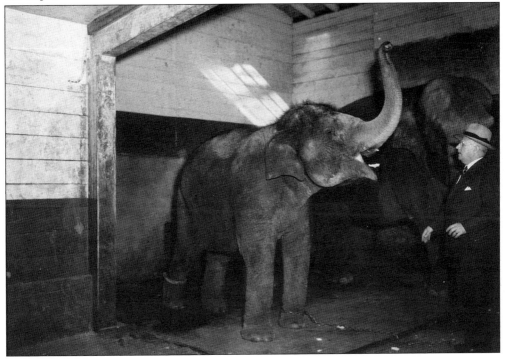

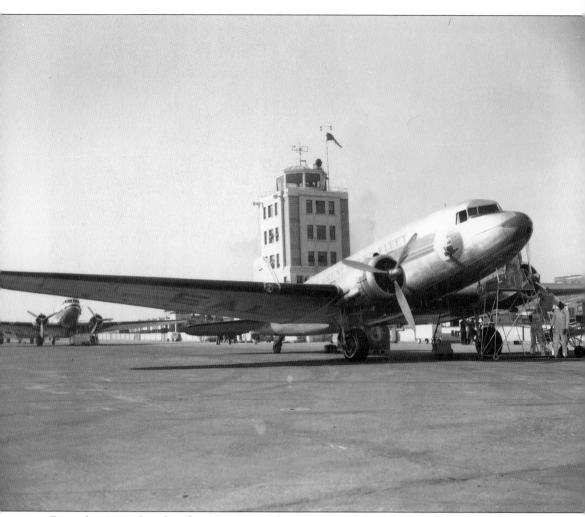

From the time of its founding in 1837 as the terminus of the Western & Atlantic Railroad, Atlanta has remained an important transportation center. Recognizing the importance of air travel, regular air service in Atlanta began at Candler Field in May 1928. This scene shows the Atlanta Municipal Airport in the 1940s.

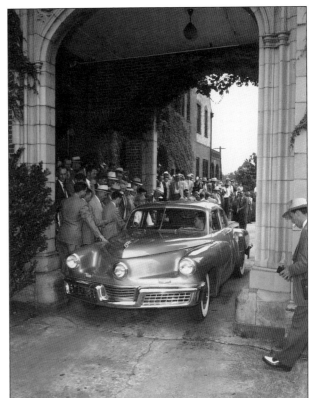

Designed by Preston Tucker, the Tucker automobile—pictured at East Lake Country Club in 1948—was truly a car ahead of its time. The vehicle featured three headlights (the middle one moved with the steering wheel), and boasted safety features such as disc brakes and a padded dash. Only 49 of these cars were ever built.

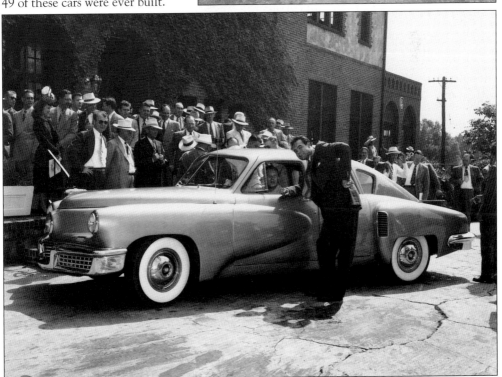

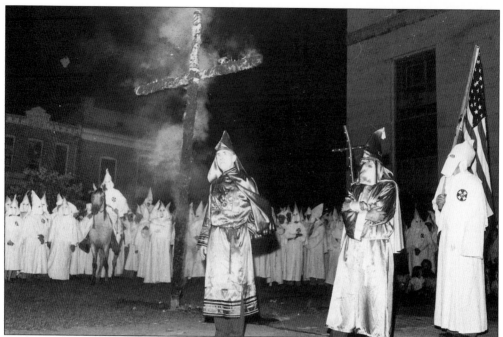

While first formed in the Reconstruction-era South, the Ku Klux Klan enjoyed a resurgence following the anti-Semitism surrounding the 1915 lynching of Leo Frank (see pages 122–123). By the 1920s, the Ku Klux Klan expanded to the North and claimed a national membership of 6 million. Atlanta was the headquarters of the "Invisible Empire" through most of that decade, and boasted among its ranks notable Atlanta clergy, judges, and politicians—including the city's mayor.

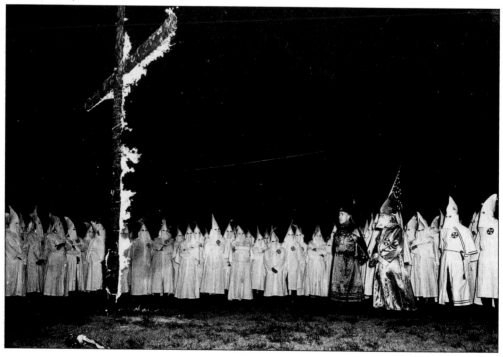

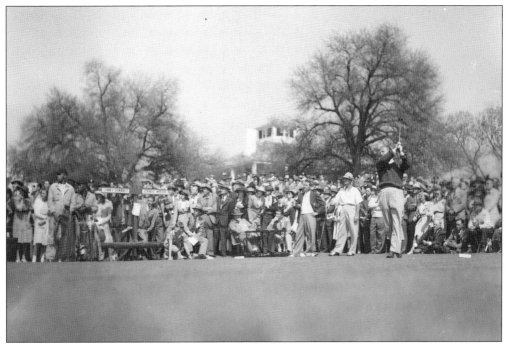

Shown here are scenes from the Masters tournament of April 1940; Jimmy Demaret won the tournament that year with a score of 280. Started by Atlanta golfer Bobby Jones in 1934 and hosted by the Augusta National Golf Club, this annual golf tournament and Georgia tradition has, since 1940, been held the first full week of April, when many of the state's prized azaleas and dogwoods are in bloom.

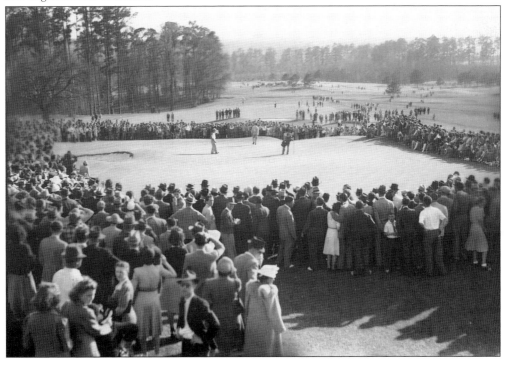

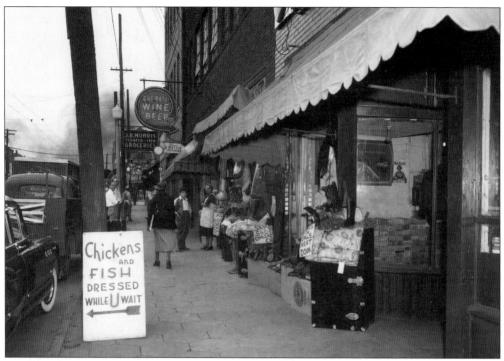

Merchants on Peters Street in southwest Atlanta are pictured *c.* 1950.

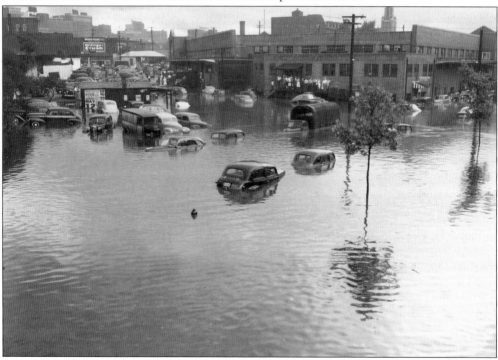

A flood in downtown Atlanta, behind the Municipal Market on Edgewood Avenue, was photographed in the early 1940s. Ironically, the market advertised itself as "all under one roof, comfortable rain or shine."

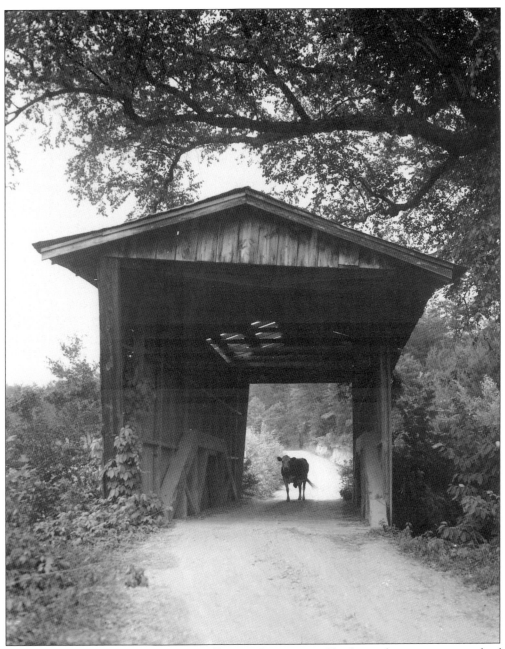

Rural scenes, such as this one of a cow silhouetted in a covered bridge in the mountains north of Atlanta, were typical of country landscapes Johnson photographed for the Atlanta newspapers' Sunday magazine.

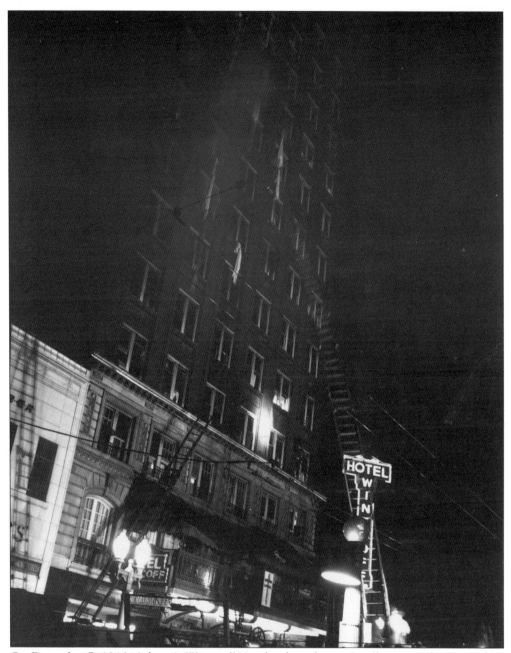

On December 7, 1946, Atlanta's Winecoff Hotel—then the city's tallest—caught fire, killing 119 people. Built in 1913, the hotel had neither fire escapes nor a sprinkler system; the city's new fire code did not apply to older buildings. The Winecoff disaster still bears the dubious distinction of being the worst hotel fire in American history.

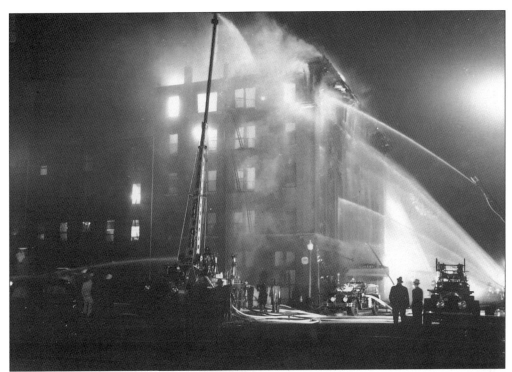

Pictured here are scenes from the Terminal Hotel fire on May 16, 1938. The five-story structure, located at Spring and Mitchell Streets, across the street from Atlanta's rail station, was engulfed in flames minutes after the fire alarm sounded. The roof collapsed shortly after firemen arrived, hindering rescue efforts. Thirty-four people died in the blaze, making it Atlanta's worst, until the Winecoff Hotel fire of 1946 (see opposite page).

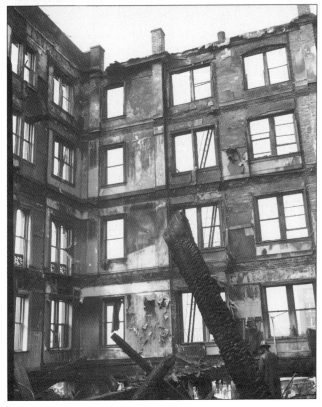

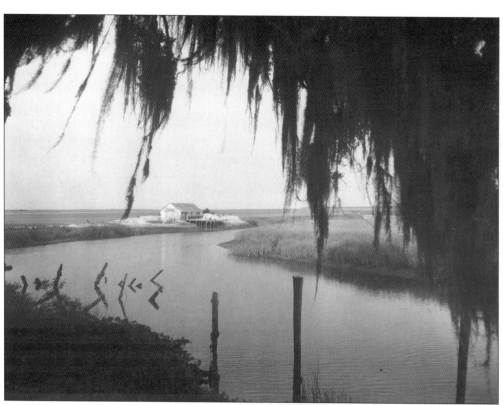

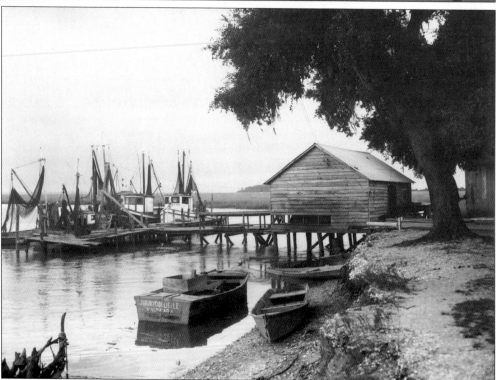

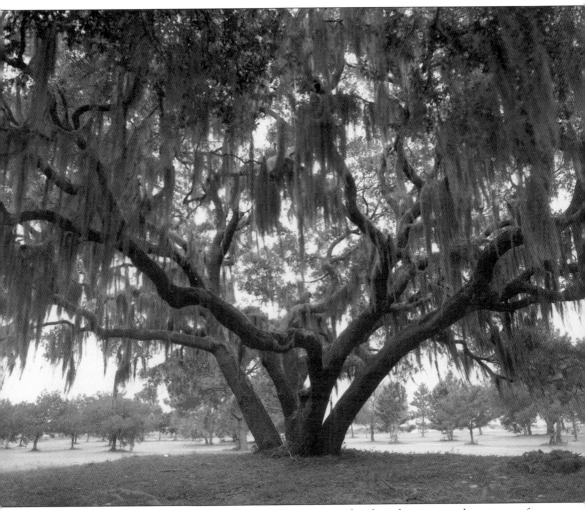

Located just a few hours from the city, the Georgia coast has long been a popular getaway for many Atlantans. Here, in places such as Brunswick, Savannah, St. Simons Island, and Jekyll Island, photographers and sightseers are treated to breathtaking scenes of marshes, weather-worn fishing boats, and graceful live oaks covered in Spanish moss.

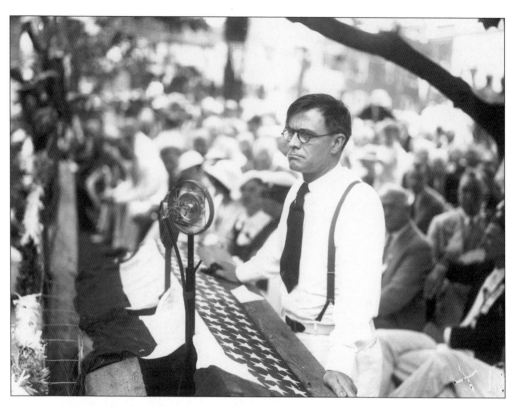

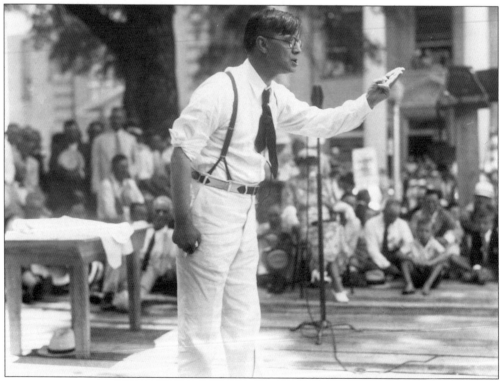

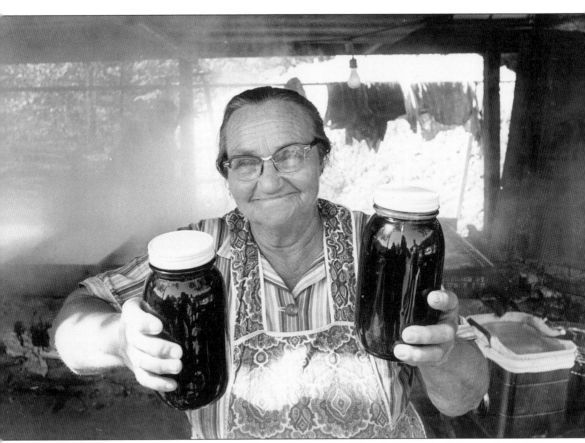

Although Bill Wilson covered a range of events, the people he photographed were perhaps his favorite subjects. Concerning subjects such as this north Georgia woman, Wilson said, "With a camera . . . I met people different than me but I felt I could learn something from every one of them." (Photograph by Bill Wilson.)

Georgia Governor Eugene Talmadge is pictured during his 1946 (opposite page, above) and 1940 (opposite page, below) campaigns. Talmadge was a colorful orator and his campaign rallies were often a combination of politics, barbecue, and country music. Talmadge's three terms as governor were characterized by his passionate defense of the state's rural population and its agrarian culture. Marion Johnson's photography of the Georgia countryside (above) often stylized Talmadge's ideals as well.

Three

BILL WILSON

Bill Wilson's photography won him many awards and prizes of recognition, but his most celebrated single photograph is undoubtedly that of the J.P. Love family reunion (pages 64–65). The image won numerous honors—including the Sigma Delta Chi (professional journalism fraternity) National Picture of the Year and the U.S. Camera-Rosecrans Award from the National Press Photographers Association—and was reproduced in *Time* magazine.

William Bryan Wilson was born February 1914 in Henry County, Georgia, and became interested in photography while studying for a degree at Georgia Tech. Hired by the Associated Press's Atlanta bureau, he worked for five years as a wirephoto operator, darkroom technician, and emergency cameraman before getting his break at the *Atlanta Constitution* in 1937, when he was hired by Kenneth Rogers. Wilson worked at the *Constitution* until 1943, when he left to serve as a Navy photographer in the Pacific; one of his duties was to install reconnaissance cameras on airplanes. Following the war, Wilson returned to Atlanta, where he worked at the *Constitution*'s competitor, the *Atlanta Journal* (the two papers merged in 1950).

During his 40 years of photography, Bill Wilson specialized in political coverage, and was particularly identified with and respected for his work during the turbulent 1960s. When Wilson retired in 1979, both houses of the state legislature passed resolutions praising him for his work and his professionalism. Wilson died in August 1993.

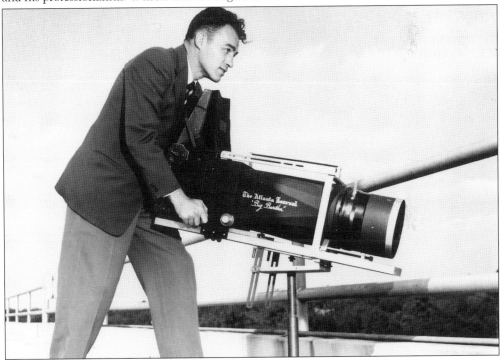

Bill Wilson poses with "Big Bertha," a 75-pound camera created in the 1950s to produce overhead images of football games. During his early years as a photojournalist, Wilson primarily covered sporting events.

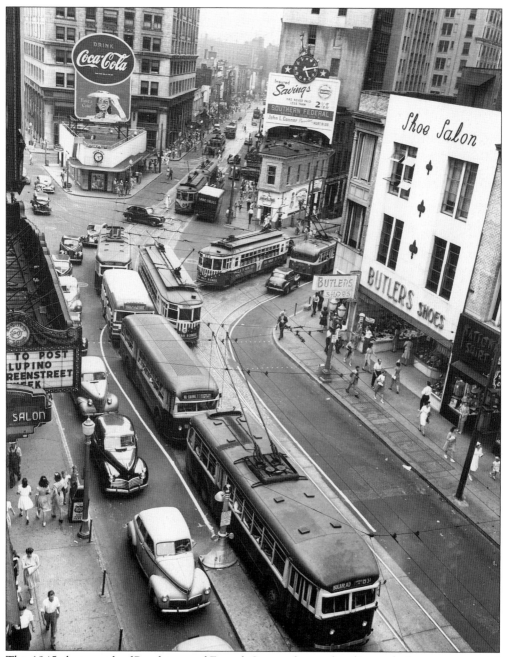

This 1945 photograph of Peachtree and Forsyth Streets shows a bustling and vibrant commercial center packed with shoppers and trolleys during World War II. Note the advertisements urging Atlantans to buy war bonds.

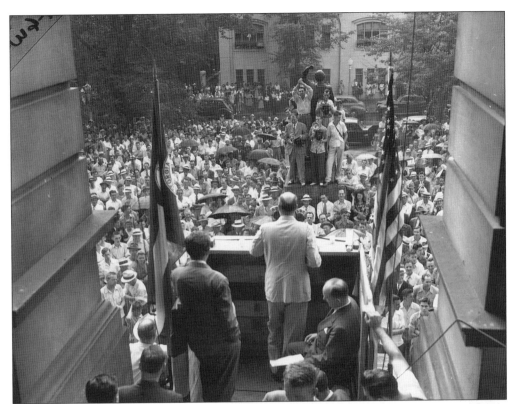

The steps of Georgia's capitol have long been a favorite pulpit from which politicians and pundits preach their messages to the people. At this July 1946 rally, Drew Pearson, a syndicated Washington columnist and radio commentator, delivered a nationally broadcast speech denouncing the Ku Klux Klan to a crowd of 2,000 people (and a pack of photojournalists, including Marion Johnson and Kenneth Rogers).

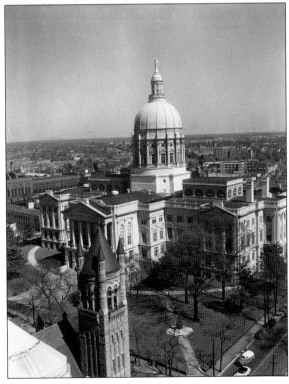

In the 1950s the glistening dome of the Georgia State Capitol was covered with gold leaf mined in the town of Dahlonega, just 45 minutes north of Atlanta. Built at a cost of nearly $1 million, the building came in $118.43 under budget.

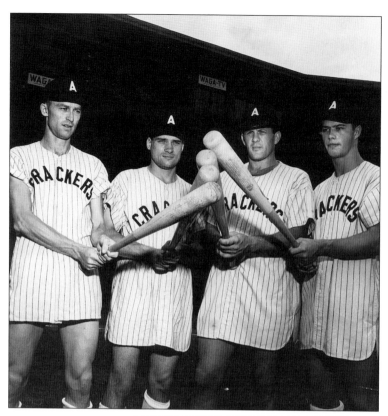

Wilson shot these photos of the Southern League's Atlanta Crackers with a promise that they would only run in the newspaper as above-the-waist shots. The uncropped originals show team members (left to right) Country Brown, Hank Eastman, Ebba St. Claire, and Eddie Matthews without their pants.

Peggy Rogers gives advice and encouragement to one of her Little League players. Rogers volunteered to coach the boys baseball team when no one else could be found.

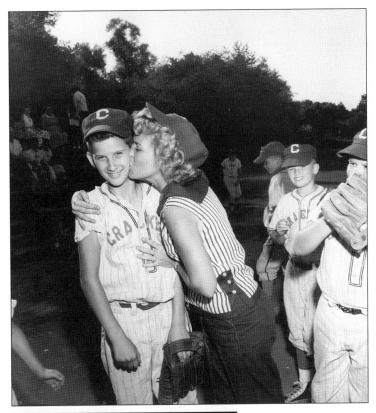

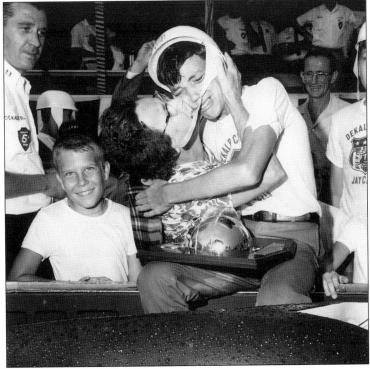

Fourteen-year-old Tony Parker, the emotional winner of a 1967 soapbox derby along Glenwood Road, is congratulated by his grandmother. From the 1940s through the 1960s, soapbox derbies received wide coverage in the Atlanta papers.

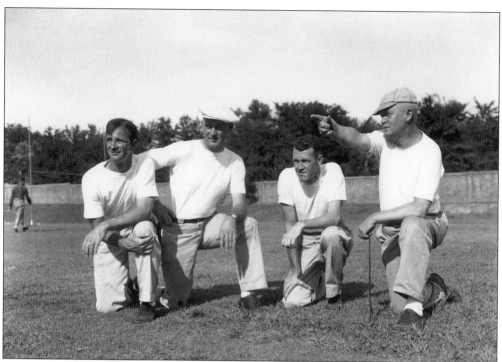

The coaches of the 1940 Georgia Tech Yellow Jackets pose for the camera: Bobby Dodd (far left) and William Alexander (far right).

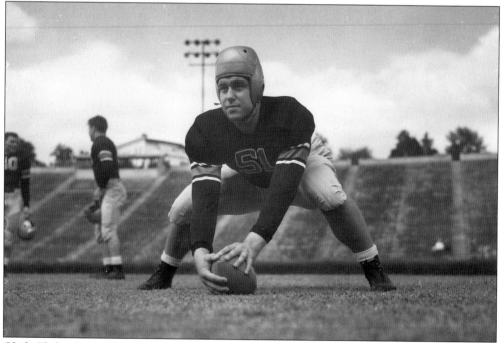

Clyde Ehrhardt was the star center for the University of Georgia Bulldogs football team, 1942. Ehrhardt played on the 1941 team that went to the Orange Bowl—Georgia's first bowl game. He also set a single-season record for interceptions that year, boasting eight.

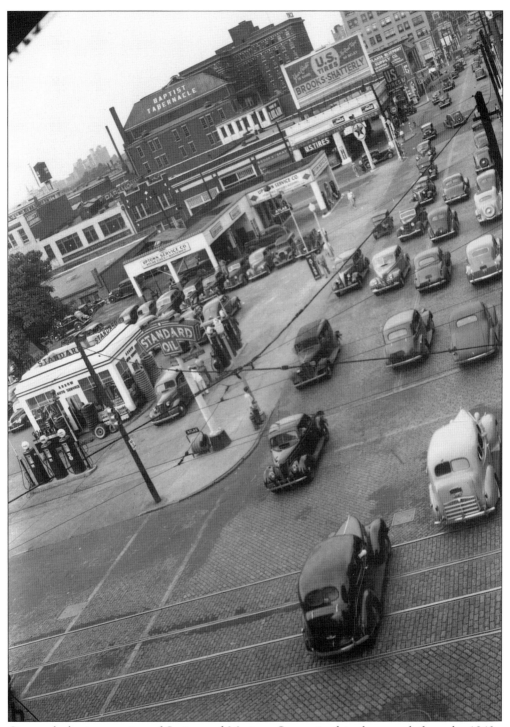

Cars pack the intersection of Spring and Marietta Streets in this photograph from the 1940s. Before interstates, Spring Street was one of Atlanta's major thoroughfares; the numerous gas stations and tire dealers seen in the left of the photo indicate its former reputation as Atlanta's "automobile street."

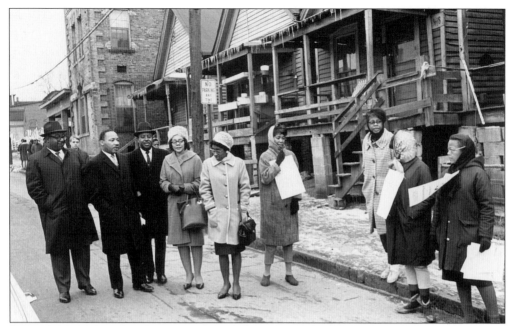

Dr. and Mrs. Martin Luther King Jr. and the Reverend and Mrs. Ralph David Abernathy tour slums on southwest Atlanta's Markham Street in 1966. Residents in this Vine City neighborhood protested rental housing conditions, which King deemed "a shame on the community."

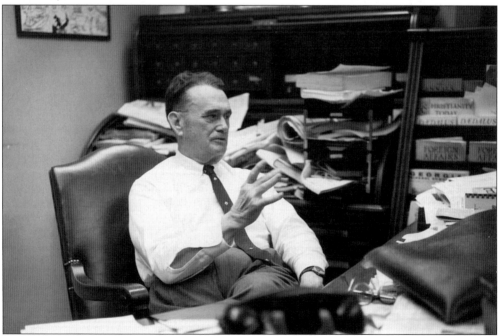

Atlanta Constitution Editor Ralph McGill, pictured in the 1960s, was arguably the most influential Georgia journalist in the twentieth century. McGill's columns favoring social justice and opposing segregation earned him designation as "the conscience of the South"—as well as many enemies.

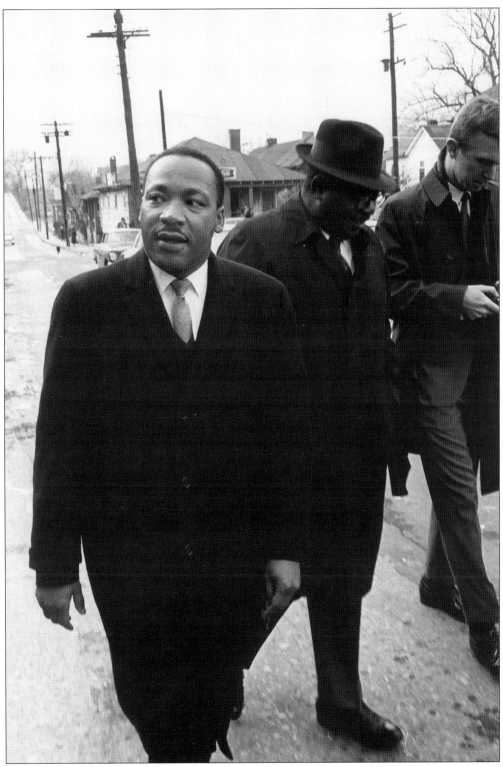

Martin Luther King Jr. is seen here during the Vine City housing protests, January 1966.

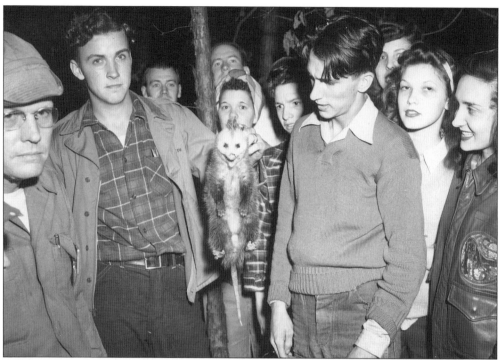

Bill Wilson and other photojournalists covered not only dramatic events, but episodes that captured small-town flavor, such as this opossum hunt and wiener roast, 1946.

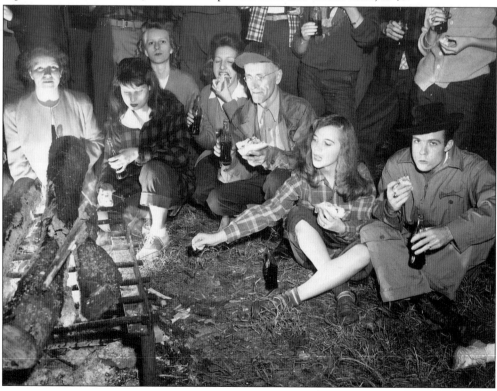

Cartoonist Ed Dodd (left), 1950, created the long-running *Mark Trail*, the first outdoor-themed comic strip. Dodd's philosophy as an artist was to arouse in people an interest in conservation.

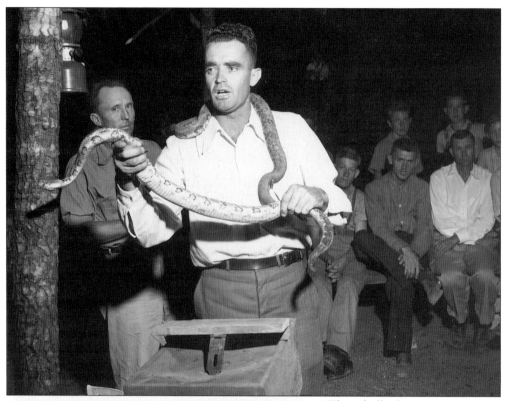

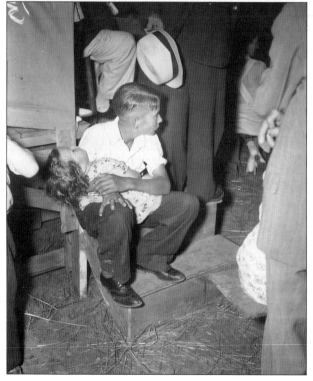

"They shall take up serpents," reads Mark 16:18 in the King James Bible. Some Protestants in the South—including this snake-handling preacher from Taylorsville, Georgia—do just that, believing that the power of the Lord will protect them from poisonous bites.

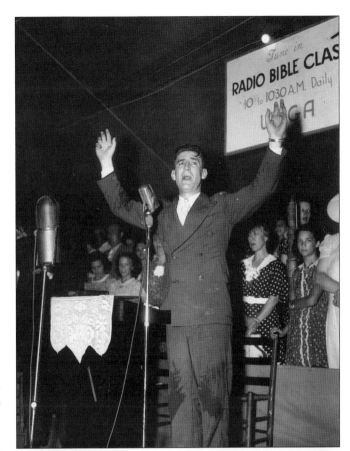

Reverend J.M. Hendley (right) and worshippers, young and old, are pictured at a tent meeting in Atlanta's Inman Park in 1939. Revivals such as this remain an important part of religious life to many in the Bible Belt.

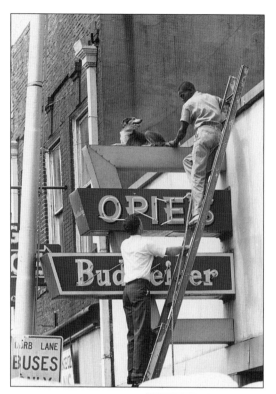

Committed to its mission of preventing neglect, abuse, cruelty, and exploitation of animals, the Humane Society boasts a distinguished history of rescuing pets in Atlanta. Left, workers with the society save a dog from atop the sign at Opie's, a bar on Broad Street, in 1966; below, R.A. Robinson emerges from a manhole on Fair Street with Kim, a puppy that had been trapped there for three days, in 1957.

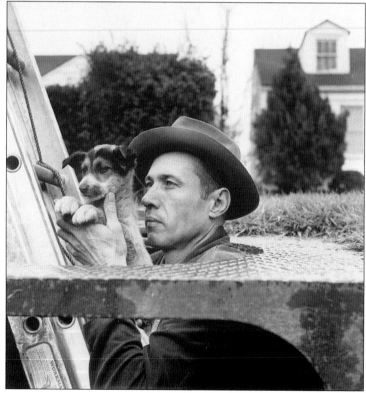

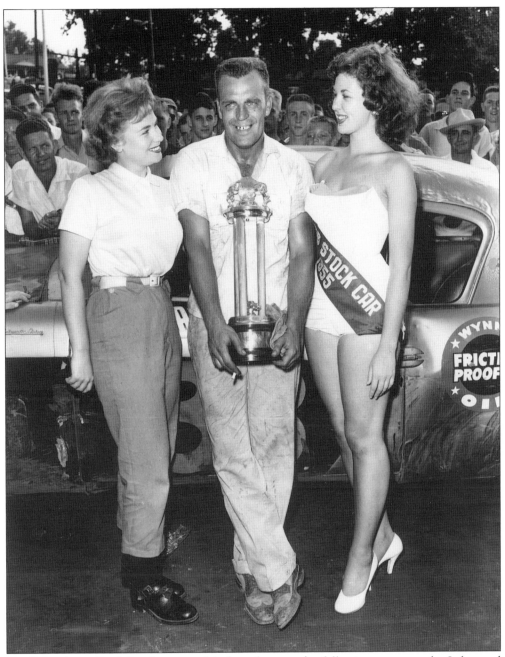

Stock car driver Paul Smith accepts his first-place trophy following a race at the Lakewood Fairgrounds track. Said Wilson, "They always had a beauty queen or something who always snuggled up and kissed the winner of the race."

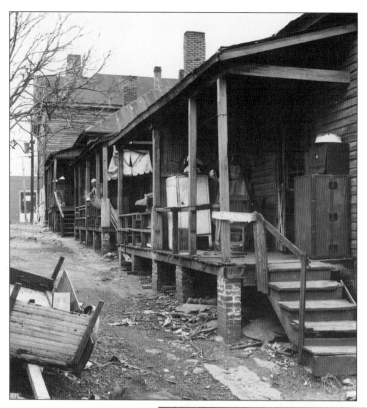

The aged and deteriorating houses surrounding downtown, such as this one in 1952, were mostly razed through urban renewal, slum clearance, and highway construction projects. These buildings sat on the future site of Capitol Homes, a government-funded public housing project.

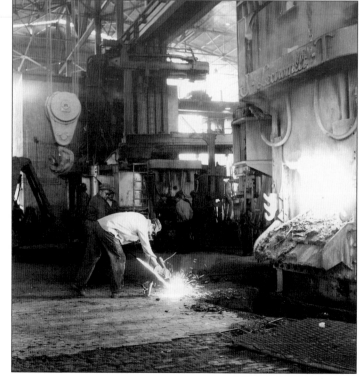

Red-hot steel, fiery furnaces, and giant machinery mark the interior of the Atlantic Steel plant, 1950. In the 1950s Atlanta's own steel mill processed thousands of tons each day.

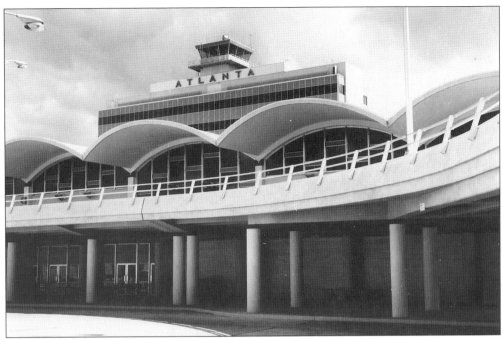

Marking the beginning of the "jet age" in Atlanta, the city's new airport building opened in May 1961 as the largest single terminal in the country.

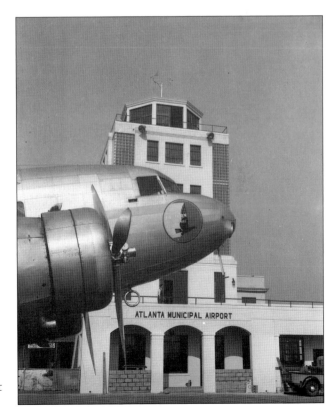

An Eastern Airlines plane appears here in front of Atlanta Municipal Airport at Candler Field. By the 1940s, Atlanta's airport was one of the country's busiest, and was the first with an air traffic control and instrument approach system.

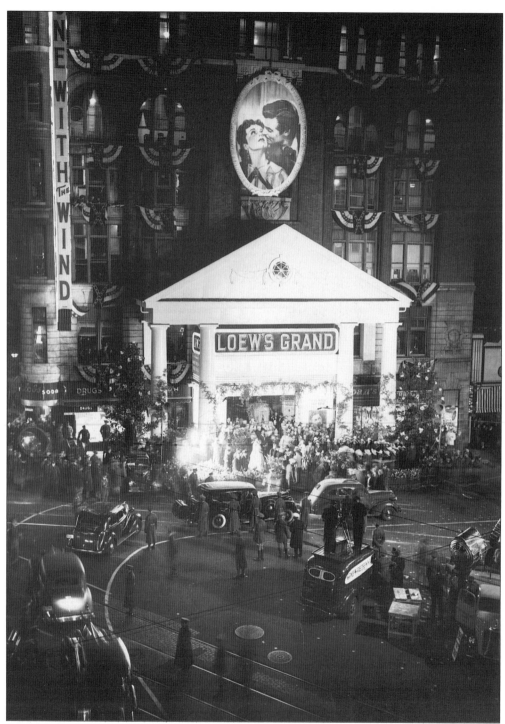

A state holiday was declared on December 15, 1939—the day of the star-studded *Gone With the Wind* movie premiere. For this momentous occasion, Loew's Grand Theater was outfitted with a facade of the fictitious Twelve Oaks plantation house and bathed in the greatest wattage of lights ever used for a film premiere.

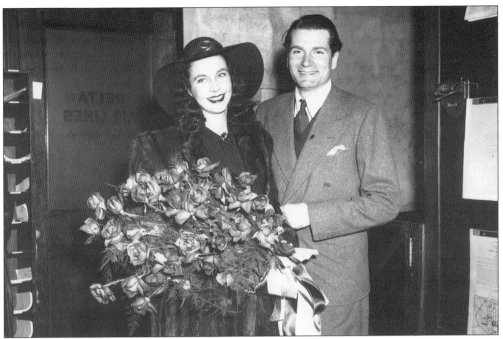

Arriving in Atlanta for the premiere of *Gone With the Wind*, Vivien Leigh's American motion picture debut, Leigh poses with actor and future husband Laurence Olivier.

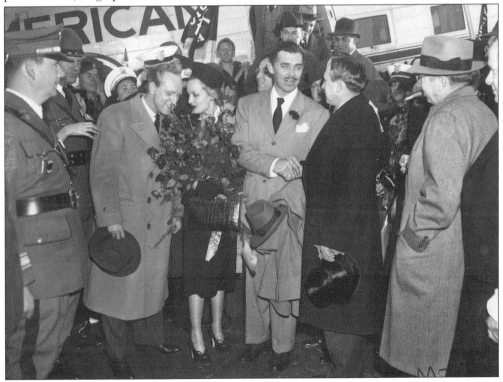

Gone With the Wind star Clark Gable, accompanied by his wife, Carole Lombard, and bandleader Kay Kyser, arrives at Atlanta Municipal Airport for the movie's gala premiere.

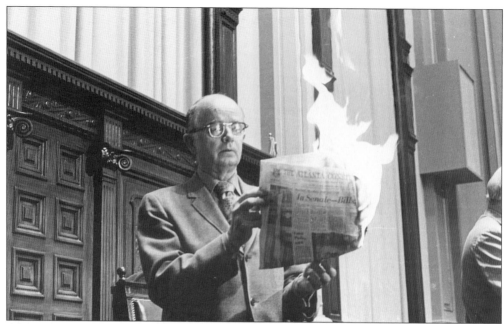

After delivering a 30-minute denunciation of the Atlanta newspapers, Lieutenant Governor Lester Maddox burned a copy of the *Atlanta Constitution* to protest an article critical of the state senate. After hearing about Maddox's action, photographer Bill Wilson asked him to repeat the stunt and Maddox happily obliged.

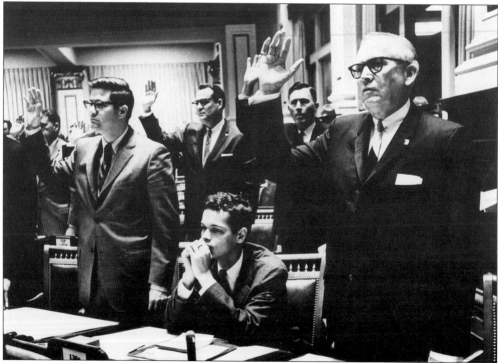

The 1966 swearing-in ceremony of the Georgia State Legislature was marked by a refusal to seat newly elected representative Julian Bond, citing his opposition to the Vietnam War.

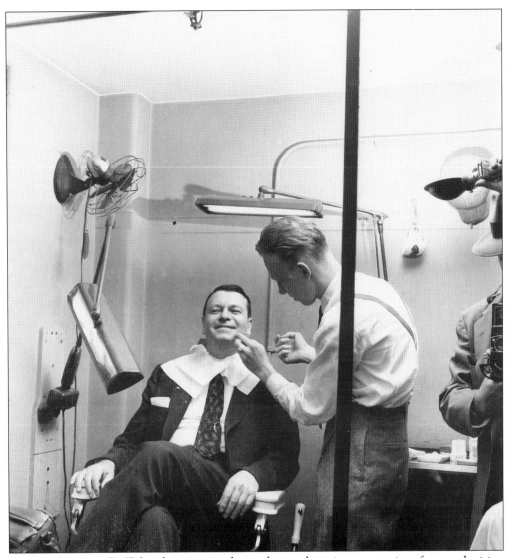

Senator Herman E. Talmadge sits in the makeup chair in preparation for a television appearance. Bill Wilson's own reflection can be seen shooting the photograph in the mirror at right.

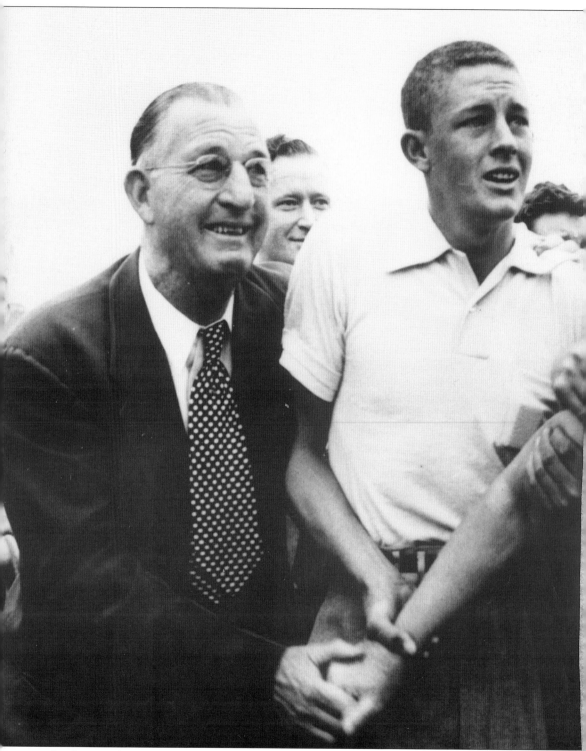

In this award-winning photograph, family members clutch Mrs. J.P. Love at Atlanta Municipal Airport as she awaits the arrival of her son, Private Crawford H. Love, who had been a prisoner

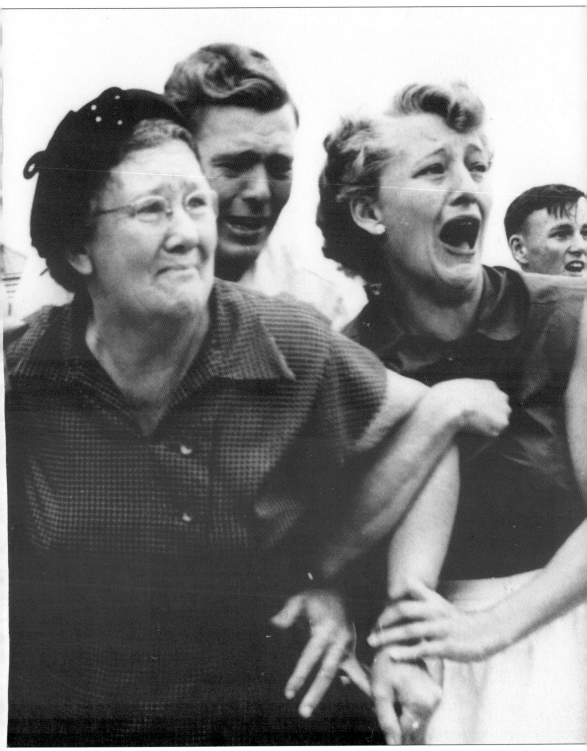

of war in Korea for 27 months.

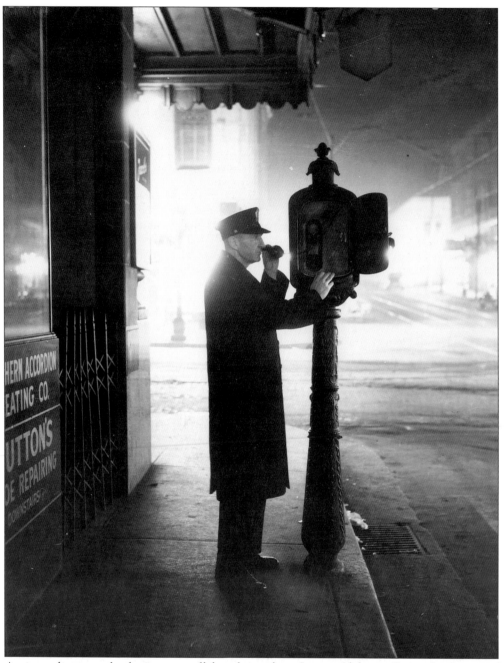

A city policeman checks in at a call box located on Lower Alabama Street (now part of Underground Atlanta). The construction of viaducts over downtown rail lines to alleviate traffic led to a one-floor elevation of the street level and the virtual abandonment of the original ground-floor storefronts beneath. (Photograph by Kenneth Rogers.)

Four

KENNETH ROGERS

A native Georgian, Kenneth Gibson Rogers was born in 1907 in the small town of Camak. At age 15, Rogers started as a *Constitution* office boy, assisting photographers Francis Price and Tracy Mathewson, beginning a long career in photography. During the next 50 years, he would help to change the face of newspaper photojournalism.

When Francis Price died in 1928, Kenneth Rogers was chosen to replace him as chief of the photography department. Under Rogers's direction, the *Atlanta Constitution* became one of the first newspapers in the South to credit individual photographers and to hire them on a salaried basis. Following his paper's merger with the *Atlanta Journal* in 1950, Rogers served as head of photography for the *Journal-Constitution Magazine*, where he became best known to Atlantans for his rustic mountain landscapes, which he considered his trademark, and moody vistas of Georgia's coastal marshes and inlets. He retired from that post in 1972.

Rogers, who died September 1989, had earned the title "dean of Southern photographers" for his innovative strategies, volume of work, lengthy career, and artistic mastery of his profession. Yet, to Rogers, his greatest achievements were simple images of the people and places in Atlanta and Georgia—kids with their bikes, folks fishing in a mountain stream, or a homecoming weekend—that he imparted with a blend of dignity and beauty.

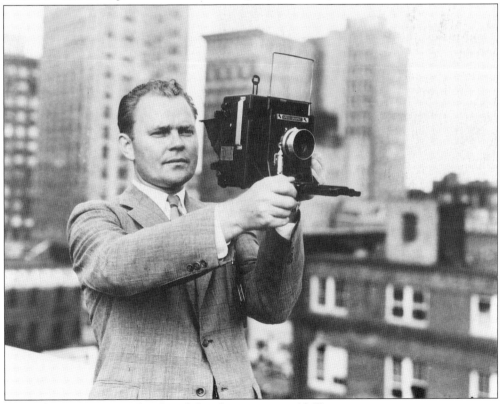

Kenneth Rogers poses with a Speed Graphic camera, *c.* 1945.

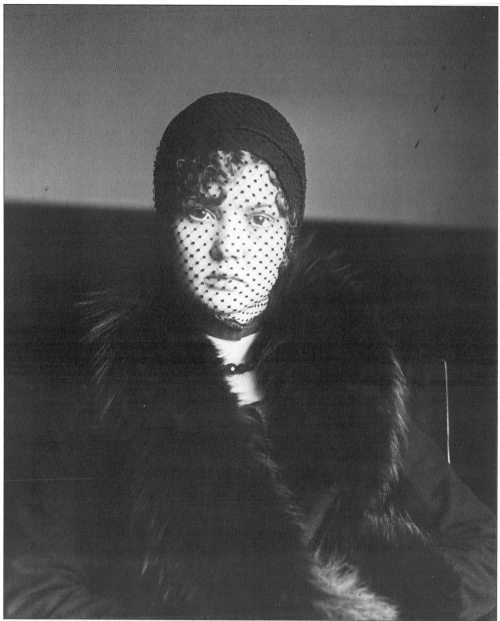

On the night of October 20, 1928, Willard Smith, a drugstore clerk, was killed in an attempted robbery. The ensuing trial of his murderers—George Harsh and Richard Gallogly, two Oglethorpe University students from socially prominent families—captured the imagination of the South. Ultimately, Harsh was convicted and Gallogly, following two mistrials, pled guilty to save his friend from the electric chair. Smith's young and attractive widow, Mary Belle (above), was the trial's center of attention, routinely escorted by her mother (opposite page, above) and once collapsing in the courtroom. The defense attorney (opposite page, below) appeals to the jury in an image taken before the prohibition of courtroom photography.

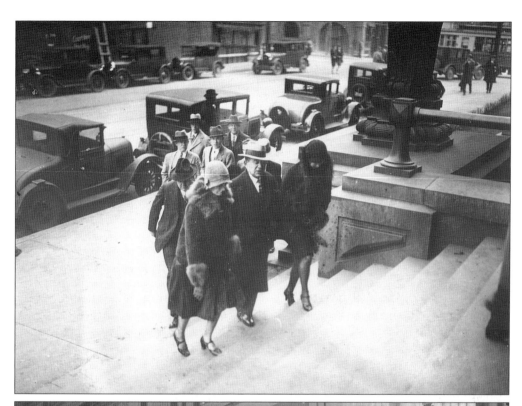

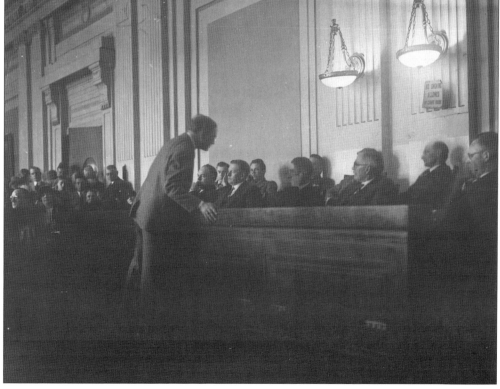

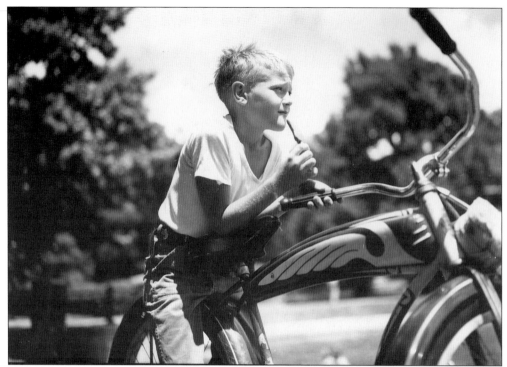

Just as many of his rural landscapes sought to idealize the South, Rogers's images of children include shots of the "ideal" Southern youth, such as a boy at Grant Park with his bike and

schoolchildren at play. Others include a boy with the straw hat and fishing pole and two smiling youngsters, which was actually taken at a 1936 political debate.

These are two Midtown structures from the Roaring Twenties: Grant Field, home of Georgia Tech football, completed in 1925, and on the horizon at left, the Biltmore Hotel, constructed in 1924 on West Peachtree Street.

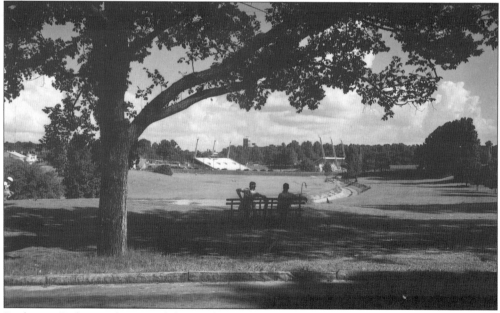

Piedmont Park was the site of the Piedmont Exposition of 1887 when its location, beyond the city limits, was still considered country. The park later hosted the Cotton States and International Exposition (1895); some of the park's landscaping and support structures date from that event.

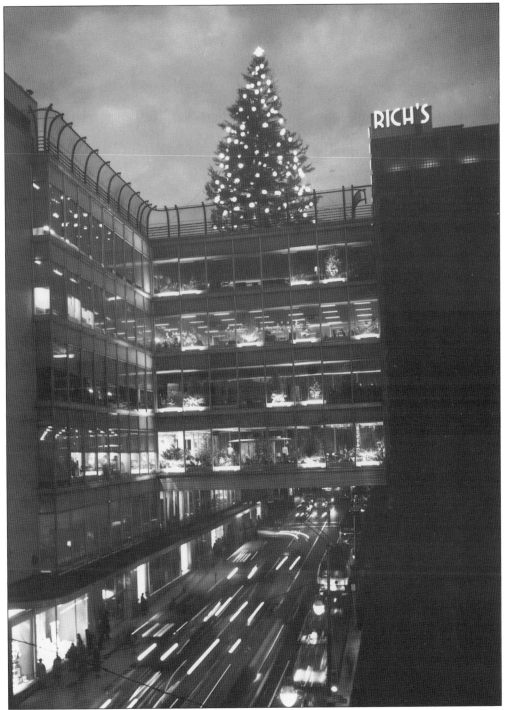

In 1948, Rich's downtown department store began a longstanding and beloved Atlanta tradition with its Thanksgiving-night lighting and holiday display of a giant Christmas tree atop the "crystal bridge." With the demolition of the Broad Street Rich's in 1994, the tree lighting moved to Underground Atlanta.

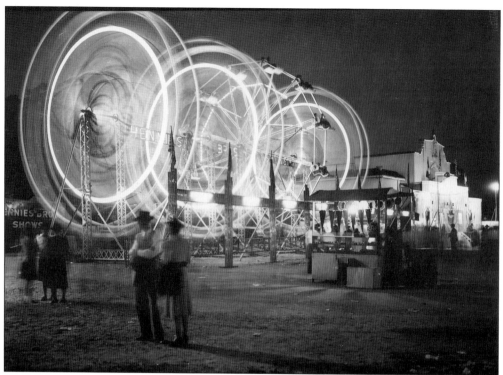

As early as 1909, Lakewood Park hosted racing events at "the fastest track in the world," but the park is perhaps best known for its annual Southeastern Fair, which started in 1916. Events as diverse as midway rides, agricultural exhibitions of poultry and livestock, art shows, and

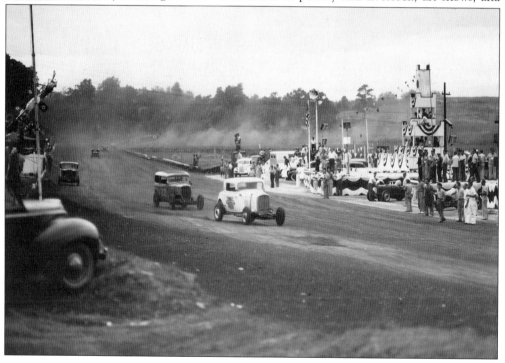

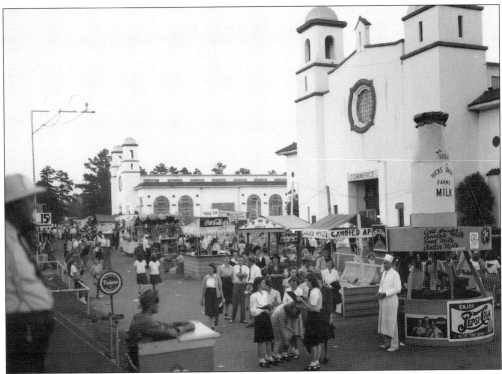

the Star and Garter hoochie-coochie show (below), entertained Atlantans until the fair's demise in 1975.

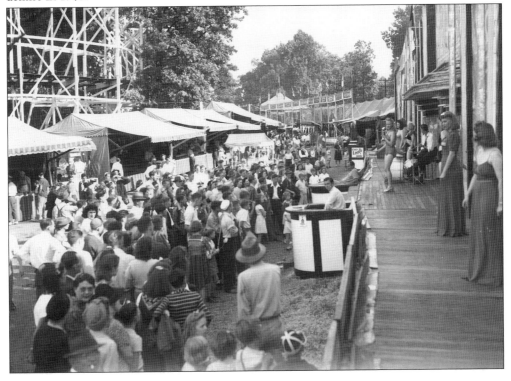

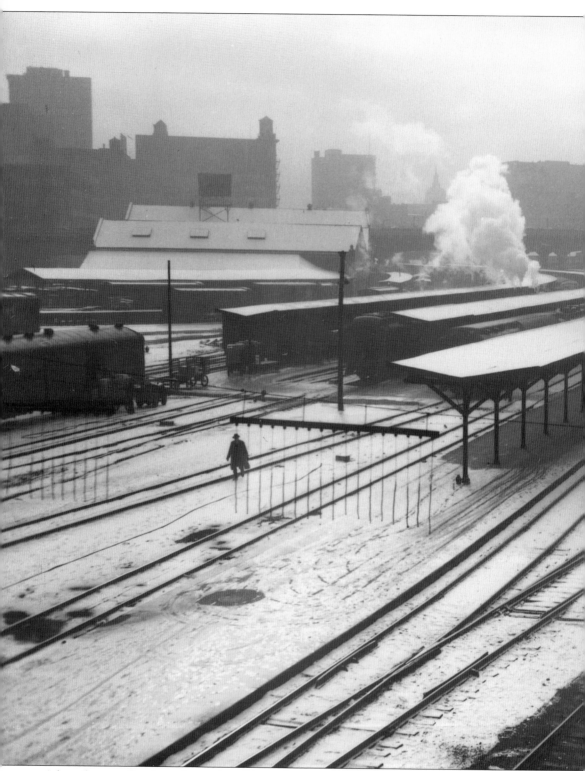

A lone figure walks along the tracks at Union Station in one of Kenneth Rogers most beautiful

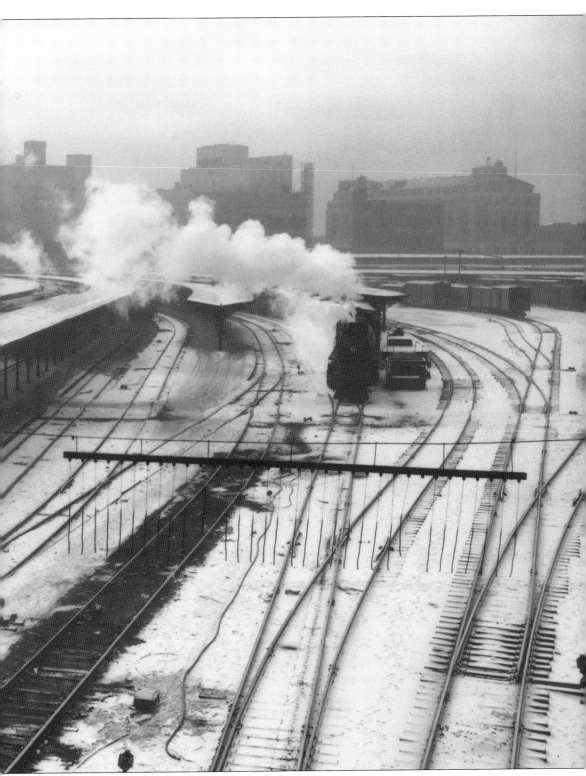

photographs, December 1935.

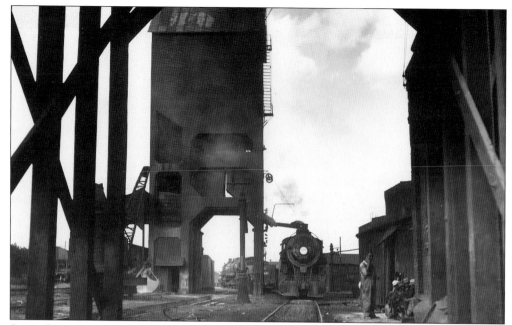

Steam locomotive No. 1295 takes on sand at Hulsey Yard, *c.* 1935. Locomotives applied sand, stored in special bins called "sand domes" on their top, to rails covered with rain or grease, to gain extra traction. At right, engine laborers take a break in the shade of the yard's roundhouse.

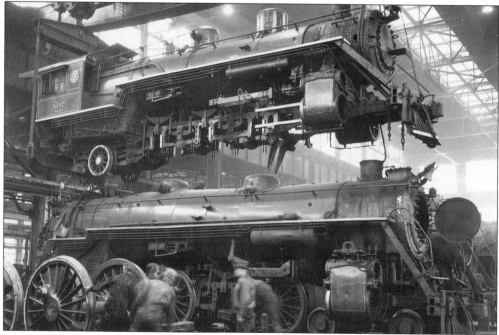

"Piggyback." Two Southern Railway steam engines are overhauled at the Pegram Shops, the company's locomotive maintenance facility in Atlanta. Pictured is the back shop at the plant, where the heaviest repairs took place. Used for hauling passenger trains, No. 1337 (bottom) was assigned to Southern's Charlotte, North Carolina, operating division. (Title by Kenneth Rogers.)

Architect P. Thornton Marye designed Terminal Station (above) as well as many other distinguished Atlanta landmarks, including the Middle East–inspired Fox Theatre. Completed in 1905, the station stood at the present site of the Richard B. Russell Federal Building.

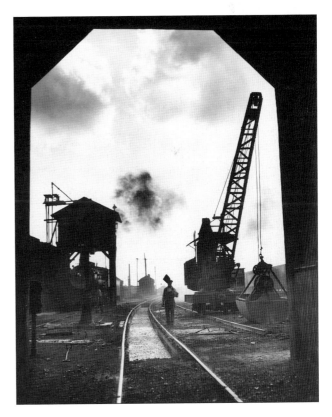

Hulsey Yard appears here c. 1935. Three railroads—the Georgia, the Atlanta & West Point, and the Louisville & Nashville—operated this sizable railroad yard near Inman Park. Located off of Moreland Avenue, the yard contained complete facilities for servicing steam locomotives between runs, including a large tower for filling locomotive tenders with coal. In between the railroad tracks in the foreground is an ash pit, where ashes from locomotive fireboxes were dumped.

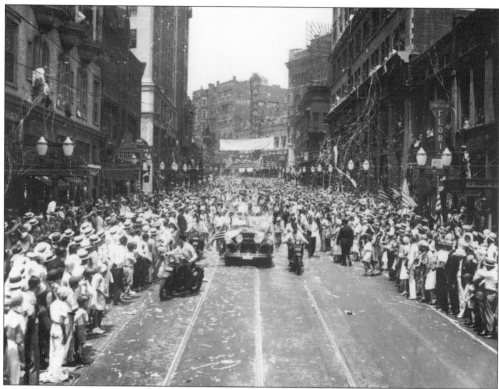

In 1930, Atlanta native Robert "Bobby" Tyre Jones became the only man to win the Grand Slam of golf: the United States Amateur, United States Open, British Amateur, and British Open. Upon his return to Atlanta, he was met with a victory parade (above), followed by

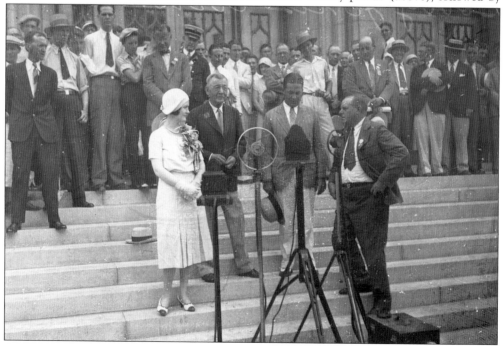

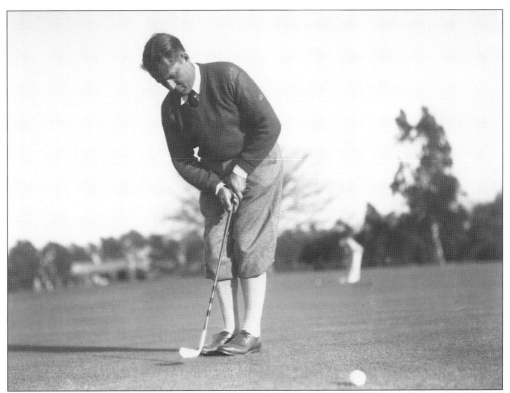

speeches at City Hall (opposite page, bottom). Above, Jones demonstrates putting for the camera, and (below) Jones (second from left) is seen with fellow golfers Olin Dutra, Charlie Yates, and Jimmy Thompson (from left to right).

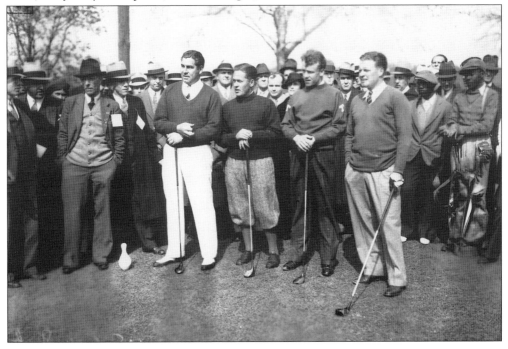

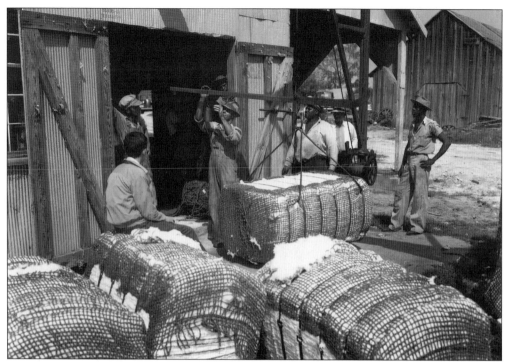

As New Deal programs reduced cotton acreage in Georgia, these scenes evoking the cotton culture of the old South—workers weighing and unloading cotton—became less prevalent. By the end of World War II, production had moved west, and Georgia's agriculture became more mechanized and diverse.

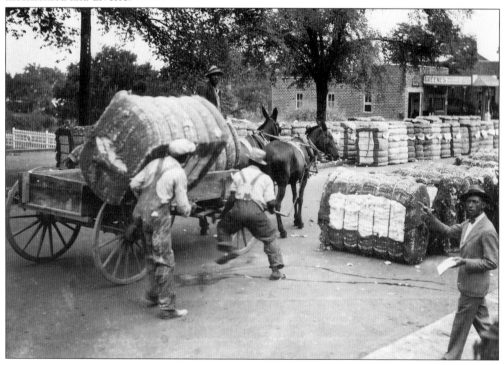

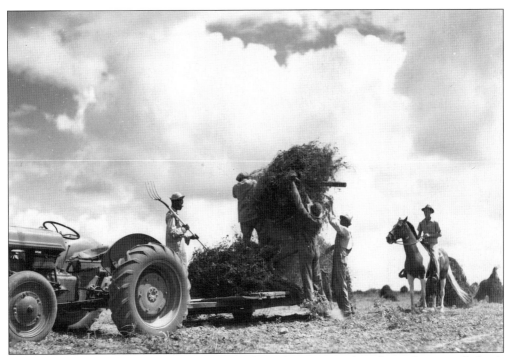

Workers harvest peanuts in the field (above), and process and package the crop (below). Peanuts became an important part of the state's economy in World War I, when U.S. troops found them a nourishing and portable food. Georgia now produces almost half of the total peanut production of the United States.

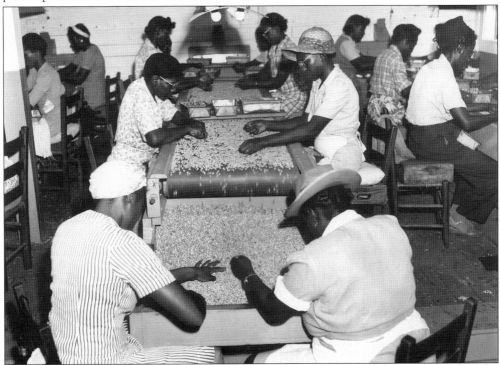

Begun as the Georgia Electric Light Company in 1884, the Georgia Power Company underwent expansion under the New Deal's Rural Electrification Administration. Power lines were extended throughout the state, and hydroelectric dams, such as the Crisp County Hydroelectric Plant near Cordele (above and opposite page, above), were constructed or purchased to meet the state's growing electrical demands.

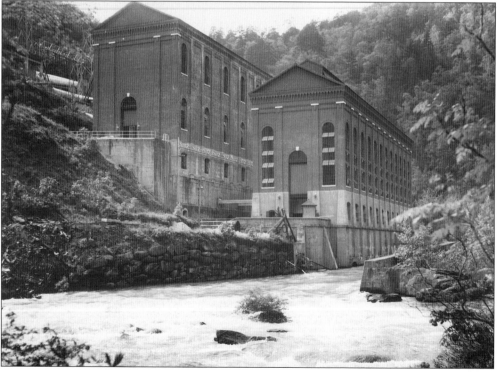

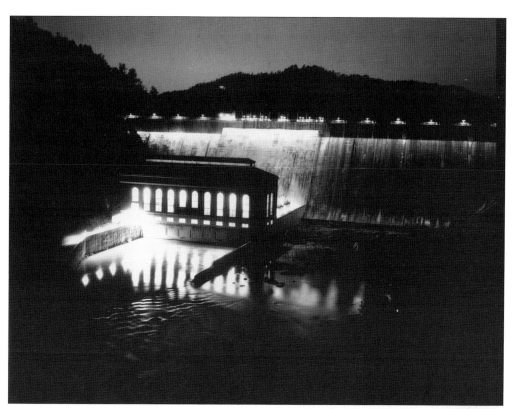

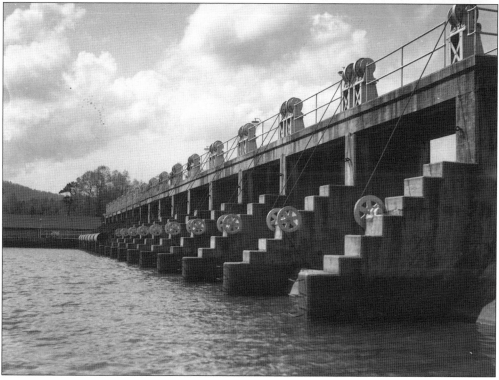

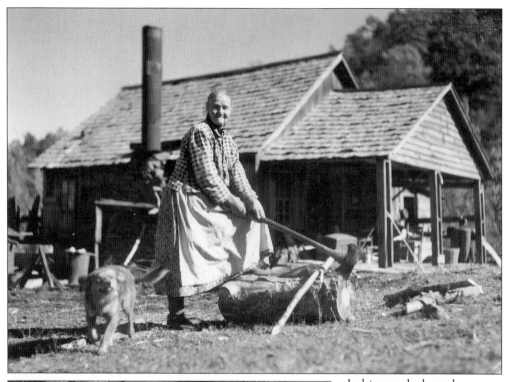

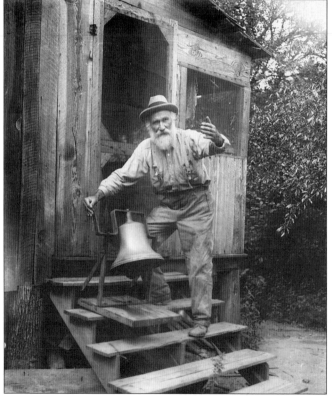

In his travels through Georgia, Rogers frequently shot scenes with interesting rural characters that caught his eye. On many, he noted their colorful names and locations, such as "Ma Georgia" (above) in Suches, 1930s, and "Uncle Mac" Galbreath (left) at his fishing camp on Lake Burton, 1925.

Rogers also photographed a blacksmith near Covington (right) in the 1930s and a farmer (below) at the Tuggle Farm at the once-rural intersection of LaVista and Briarcliff Roads in northeast Atlanta.

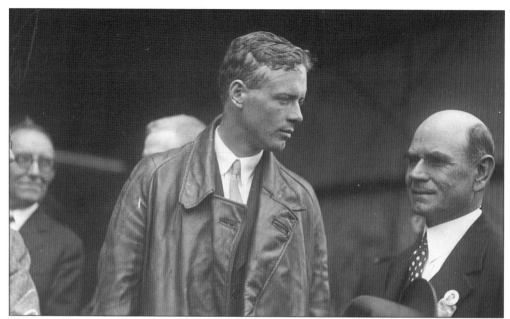

Colonel Charles A. Lindbergh is greeted at Candler Field in celebration of his historic solo flight across the Atlantic. After arriving in his trans-Atlantic plane, the *Spirit of St. Louis*, the City proclaimed October 11, 1927, as Lindbergh Day and Lindbergh Drive was named in his honor.

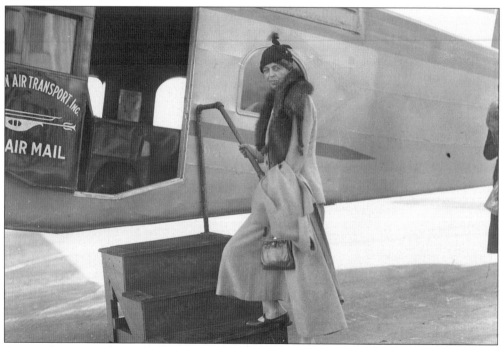

Among their many duties, staff photographers at Atlanta's papers documented the arrivals and departures of celebrities, such as Eleanor Roosevelt, at Atlanta Municipal Airport. Considered newsworthy events, the very coming and going of a big name could send photojournalists scurrying to the airport on a moment's notice.

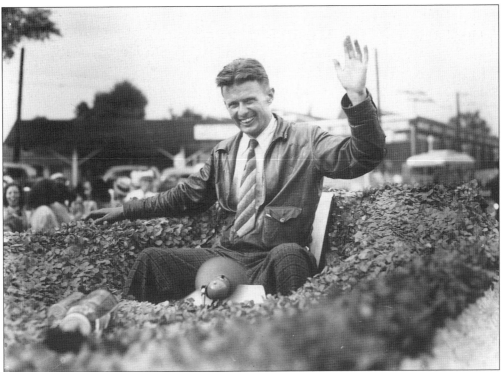

"Wrong Way" Corrigan enjoys an Atlanta parade in his honor, August 1938. Douglas Corrigan was supposed to fly from New York to California, but flew instead to Dublin, Ireland, in aviation's most famous "mistake." Claiming he unintentionally flew the wrong way, Corrigan became a national celebrity.

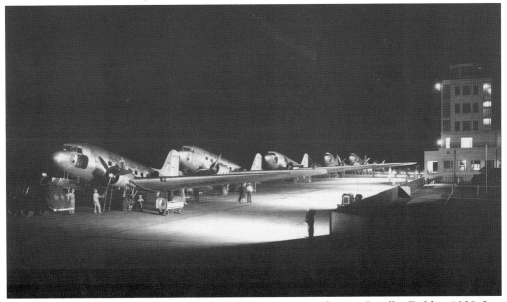

Atlanta was one of the first cities to establish an airport, purchasing Candler Field in 1929. Just as the city served as the foremost rail center in the Southeast, city leaders sought to ensure that it would also act as the leading "Terminus of the Skies."

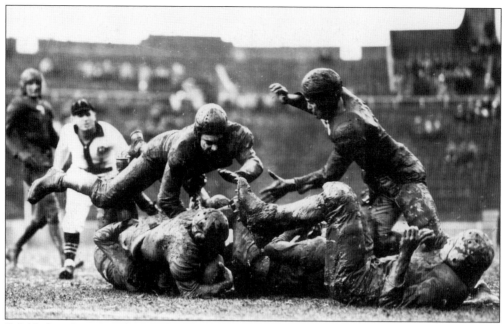

"Molded in Georgia Clay" is the title of this 1920 photograph. Late in life, Kenneth Rogers made a selection of his favorite and most artistic images, many of which he supplied with equally artistic titles, such as this one. (Title by Kenneth Rogers.)

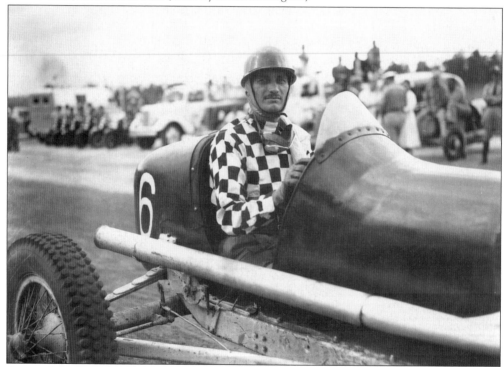

Automobile racing has been popular with Atlantans since 1909, the year the Atlanta Speedway opened (on the site that would later become the Atlanta Municipal Airport). Pictured here is a race car driver, c. 1940, at the Lakewood Park racetrack.

Although Rogers photographed many dramatic live-action shots during his career, this shot taken at the 1937 Atlanta Crackers training camp was staged to create a great sport scene; a photographer would never have been able to position himself this way during an actual game.

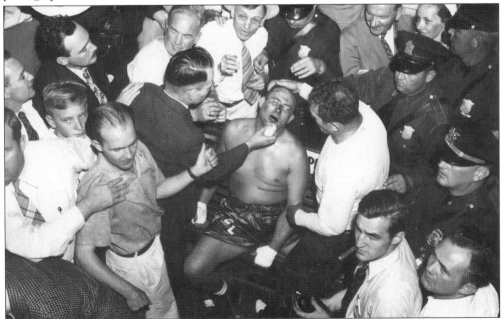

The crowd surrounds boxer Cowboy Lutrell as he lies unconscious and out of the ring. In July 1941, before more than 10,000 spectators at Ponce de Leon Park, Jack Dempsey pounded Lutrell with a series of punishing attacks before a crashing right sent Lutrell sailing out of the ring in a sensational knockout.

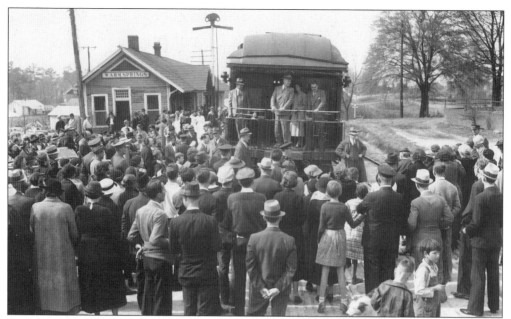

President Franklin D. Roosevelt appears on the rear platform of his train at the Warm Springs station. Roosevelt had a unique relationship with Georgia, having established a polio treatment center in 1927 at Warm Springs, where he built his home, popularly known as the Little White House.

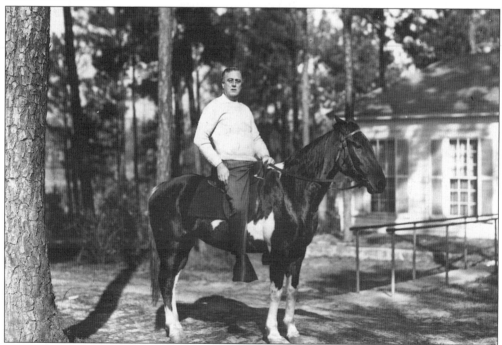

Despite the crippling effects of polio, Roosevelt enjoyed many outdoor activities, including deep-sea fishing, swimming, and sailing. Though his thigh weakness made horseback riding uncomfortable for him, he liked to ride and posed for photographers astride his horse to prove his health and vigor.

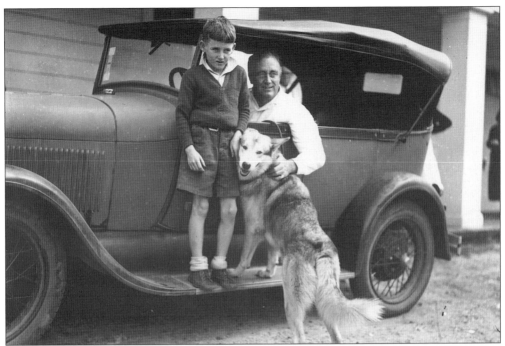

Sitting behind the wheel of his car, Roosevelt poses with a young boy and his dog.

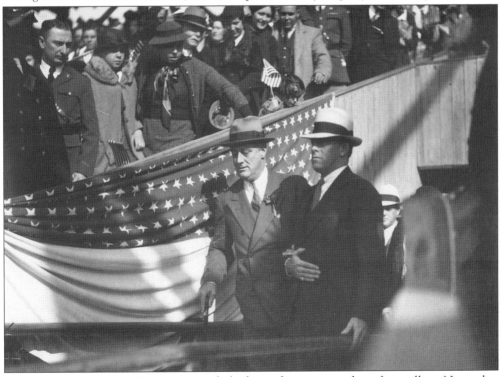

Roosevelt, walking with the assistance of a bodyguard, enters a stadium for a rally in November 1933. Many Americans were totally unaware that Roosevelt could only walk with the utility of braces, crutches, or the support of others.

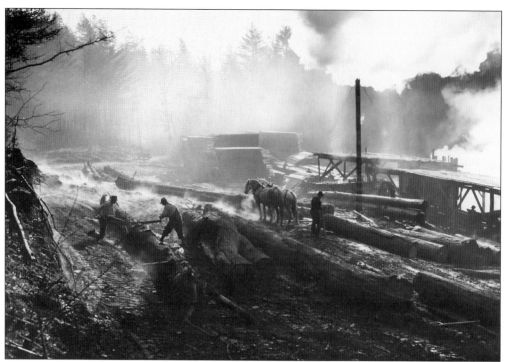

Two men are seen sawing a log in the early morning mist (above), and an elderly worker leans on his pole at a north Georgia sawmill (below) in two logging scenes. Lumbering has long been one of Georgia's main industries; in the 1940s and 1950s it enjoyed a boom period.

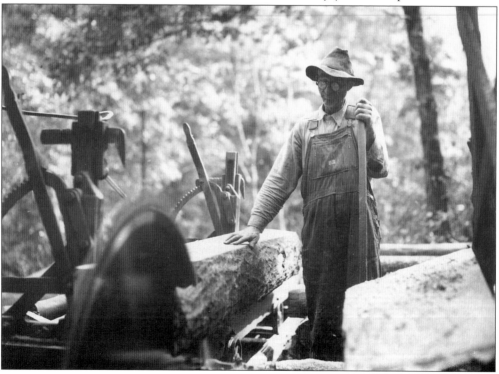

The Civilian
Conservation Corps
(CCC) was one of
the first New Deal
programs, established
in 1933 by President
Franklin Roosevelt.
Created to provide
rural employment
in environmental
conservancy, projects
included tree
planting, forestry, road
maintenance, and, as
shown here, equipment
support (right) and
surveying (below).

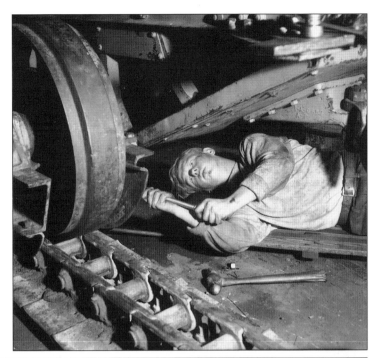

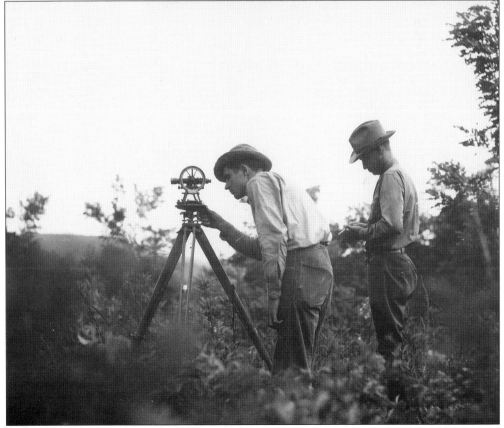

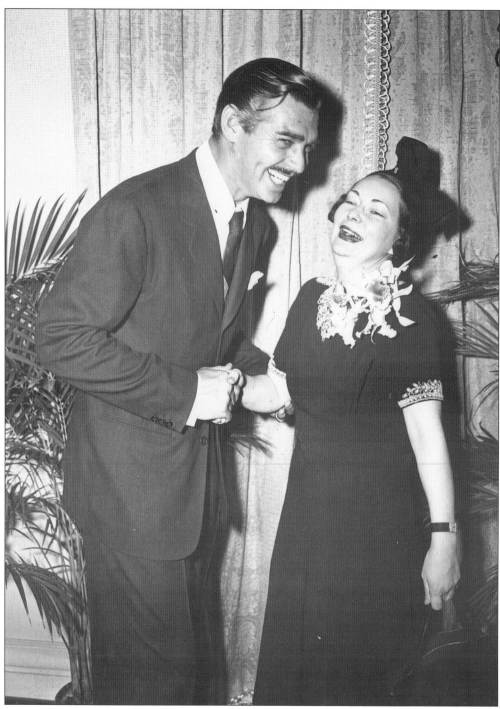

In a spontaneous burst of laughter, Clark Gable and Margaret Mitchell share an unguarded moment at the Piedmont Driving Club before the successful premiere of *Gone with the Wind*.

Kenneth Rogers noted directly on this photograph's negative that this shot of Margaret Mitchell was made for Major Clark Howell, editor and publisher of the *Atlanta Constitution*, just before she published *Gone with the Wind*. For that very reason, we know she is not reading her famed work.

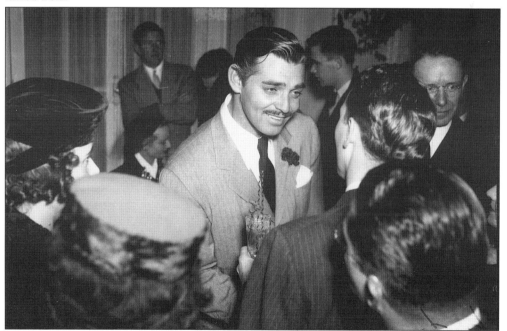

Clark Gable greets guests at a Georgian Terrace reception on the day of his arrival for the *Gone with the Wind* premiere. Atlanta's Mayor Hartsfield is pictured at right, and Gable's wife, actress Carole Lombard, can be seen seated in the background at left.

Beyond Kenneth Rogers's work as a newspaper photographer, he was well known for his nature shots of the north Georgia mountains, the coastal islands and marshes, and the south Georgia swamps and pine woods. Many Atlantans were familiar with these scenes through a series of illustrated desk calendars published by Rich's department store in the 1950s.

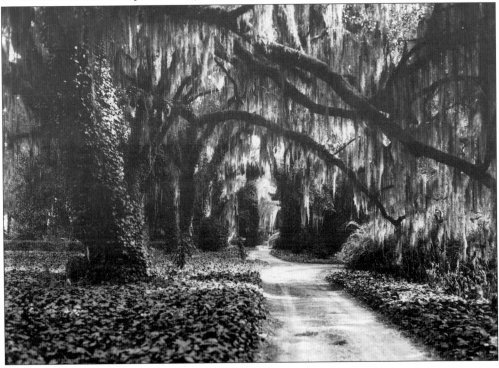

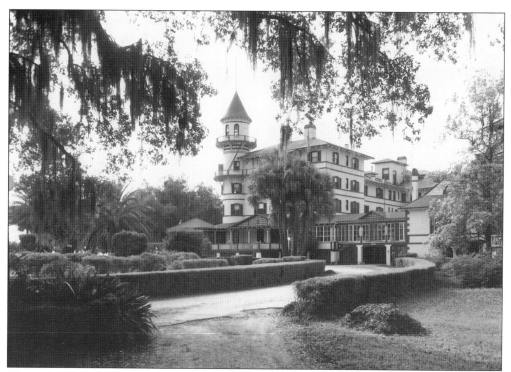

Shown here is a historic contrast of life along the Georgia coast: above, a mansion on Jekyll Island, once the exclusive retreat of some of America's wealthiest and most influential families, including the Astors and the Vanderbilts; and below, antebellum slave quarters at the old Hermitage Plantation along the Georgia coast.

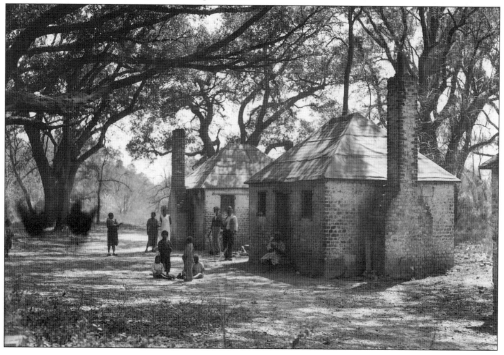

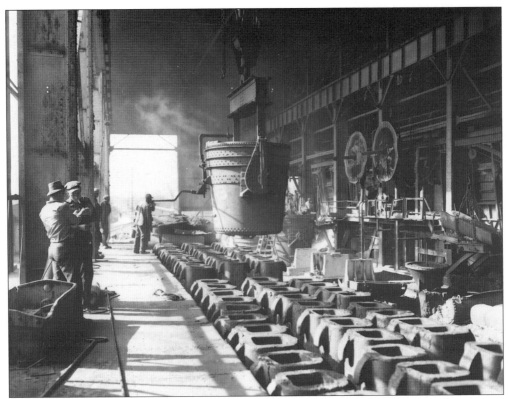

Though Georgia has had an agricultural economy for much of its history, scenes of workers at the Atlantic Steel Company in Atlanta and at Brunswick's ship-building facilities display the state's industrial capacity.

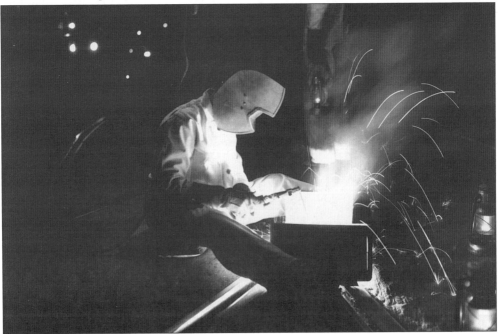

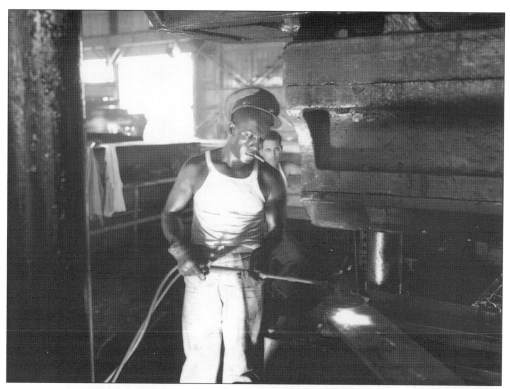

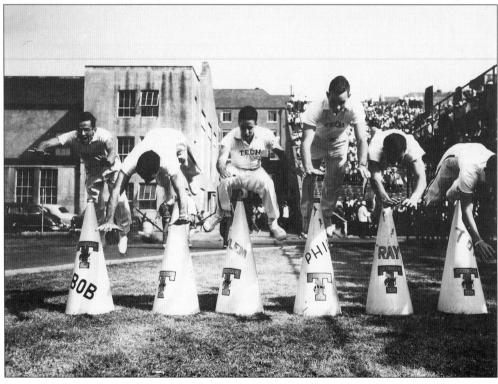

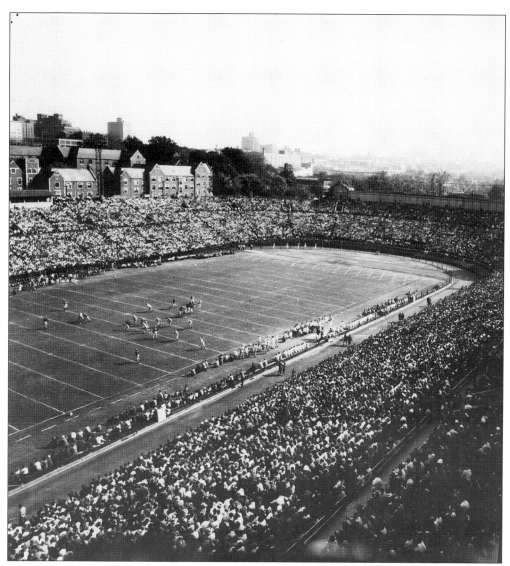

For many, Georgia Tech football is an essential part of Atlanta life, and 1952 was a standout year for the Ramblin' Wreck. The team finished the season 11-0 and defeated Ole Miss in the Sugar Bowl, but lost the national championship vote to Notre Dame. These scenes are from the 1952 homecoming game against Vanderbilt, won by Georgia Tech, 30-0.

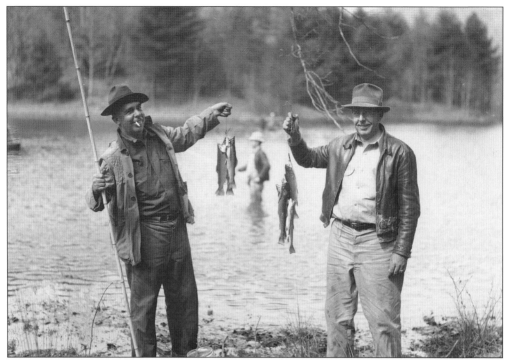

Fishing was a popular sport shared by numerous Atlanta photojournalists. As a group, many of them would take the opening day of trout fishing, traditionally April 1, and spend a few days along the mountain streams in Georgia.

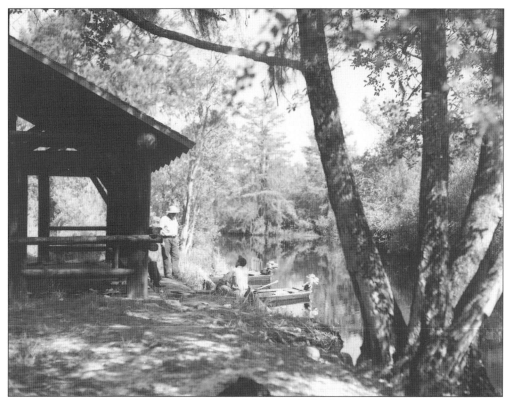

Stone Mountain (below), located just east of Atlanta, is the largest exposed mound of granite in the world. Stone Mountain Park has long served as a favorite recreation, sport, and historic site for leisure-seeking Atlantans.

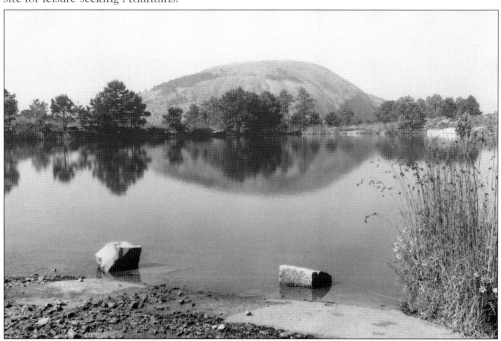

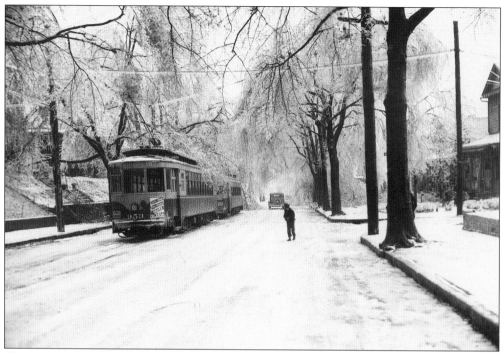

The year 1935 ended with an ice storm that paralyzed the city: two solid days of sleet, snow, freezing rain, and sub-zero temperatures resulting in ice-caked streets, a crippled power service, downed telephone and telegraph lines, and a disabled trolley system that left Atlanta virtually isolated from the outside world. Ice and snow are rare in Atlanta, but when they arrive they often bring the city to a standstill.

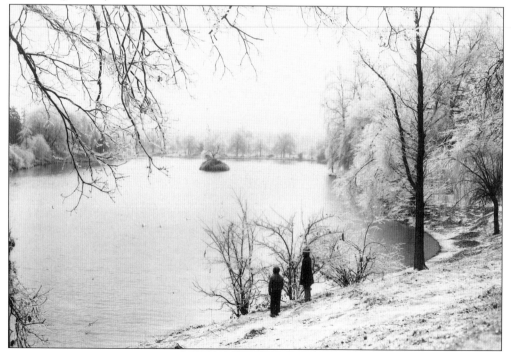

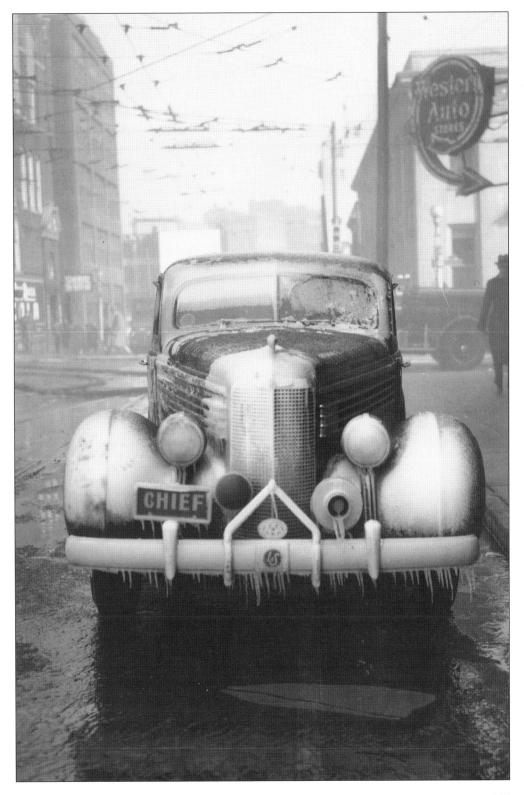

108

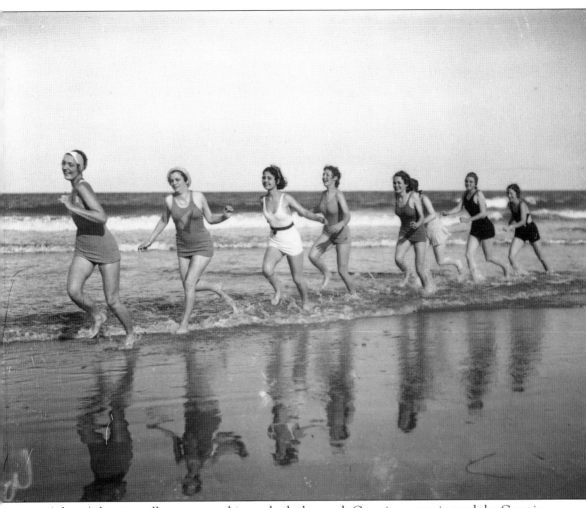

Atlanta's location allows an easy drive to both the north Georgia mountains and the Georgia coast, making them a popular weekend destination for many Atlantans. These shots on the opposite page are of Sitton's Gulch State Park (now Cloudland Canyon State Park), referred to as the "Grand Canyon of North Georgia." The one above is a typical "cheesecake" photo, which photographers frequently used during the period.

These scenes from Georgia's Fort Benning, home of the U.S. Army Infantry School, were taken in the 1940s. The importance of Fort Benning, established in 1918, grew during World War II with the arrival of the First Infantry Division and the establishment of Officer Candidate School and airborne training.

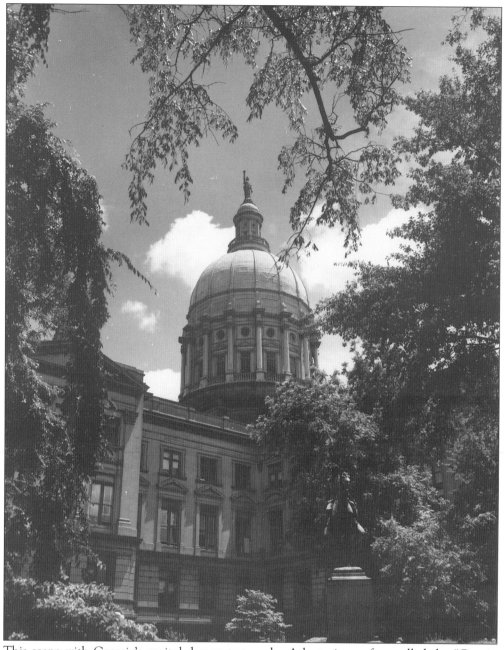

This scene with Georgia's capitol demonstrates why Atlanta is so often called the "City in the Forest."

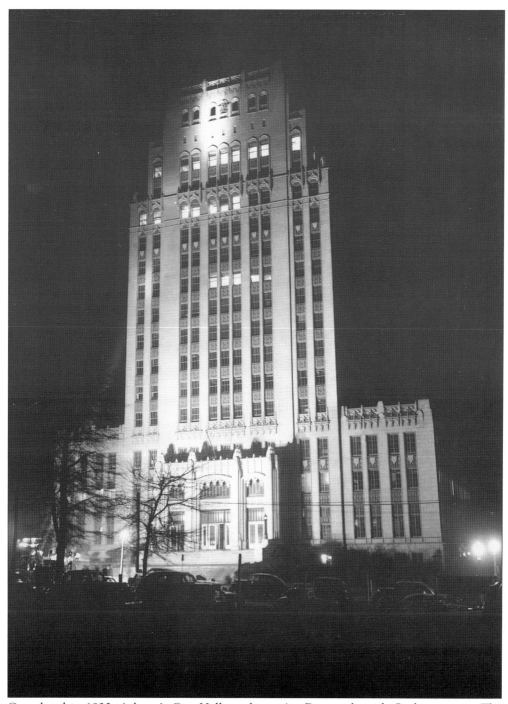

Completed in 1930, Atlanta's City Hall combines Art Deco style with Gothic accents. The building stands on Mitchell Street on the former site of the John Neal house, the location of General William T. Sherman's headquarters during the Civil War.

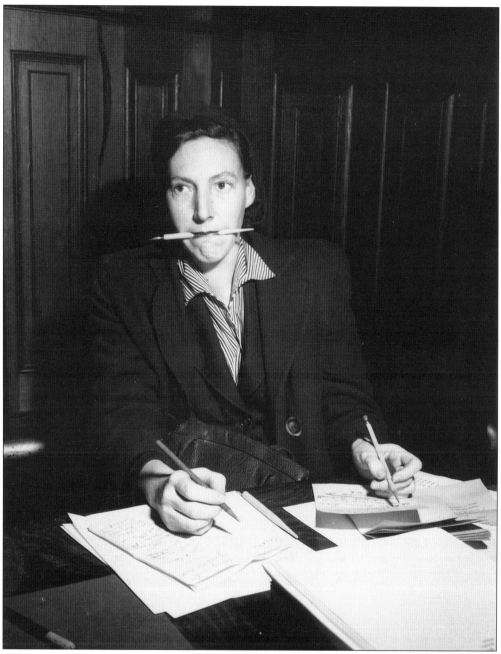

Atlanta newspaper columnist Celestine Sibley poses with her best ready-to-work attitude: a pencil in each hand and one in her mouth.

Five

THE KENNETH ROGERS COLLECTION

The images contained in this chapter are selected from photographs collected by Kenneth Rogers during his many years as head of the *Constitution*'s photography department. Many other photographers worked side-by-side with the four photojournalists featured in *Atlanta Scenes*: Tracy Mathewson, a world-renowned photographer hired to work with Francis Price; Hennis Slayton; Carl Dixson, who convinced Rogers to modernize the newspaper's equipment; Harmon Perry, the city's premier African-American photographer; and Carolyn Mackenzie, Bessie Walker Callaway, and Edna Preston, women photographers who got their big break during World War II when the men were at the war front. The images contained in this chapter could well be the work of some of these artists, but unfortunately, the photographers for these works remain unidentified. (Only two images included here have been attributed with any certainty—a scene of a Chattahoochee River bridge and a Ku Klux Klan trial, both by Guy Hayes.)

Despite that fact, these photographs appear here because they represent the same calibre of work as Rogers, Wilson, Price, and Johnson. Although the creators of the images in this chapter are unknown, the work is still invaluable, not only for the distinction of its historic documentation and the visual information it provides, but for its artistic quality as well.

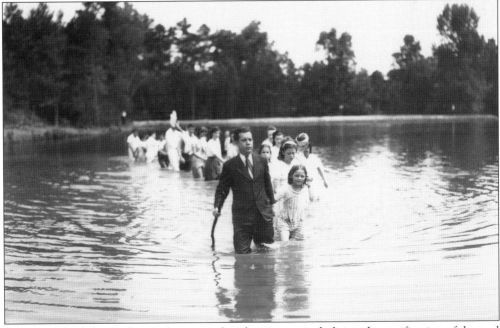

A minister leads his flock into the waters for a baptism—symbolizing the purification of the soul and the washing away of sin—in rural Georgia.

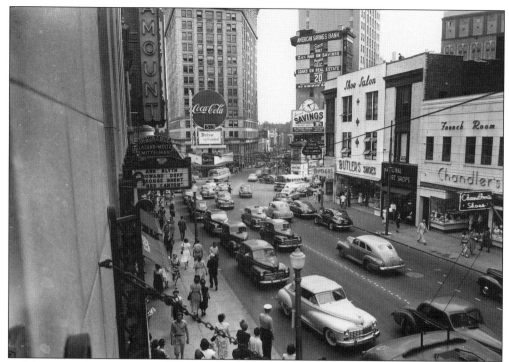

Advertisements for Coca-Cola have been a part of Atlanta's scenery since 1886. The neon Coca-Cola billboard at the intersection of Peachtree and Pryor Streets was a city landmark from 1932 until 1981.

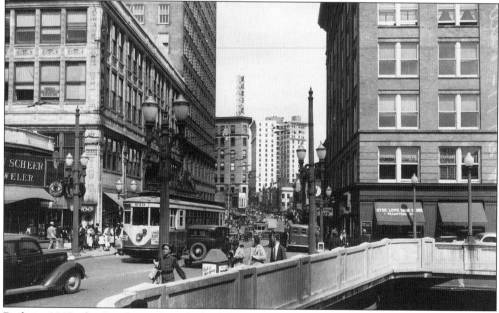

Built in 1917, the Peachtree Arcade (at left) ran along a portion of Peachtree Street known as the Great White Way for its illuminated streets and sidewalks, designed to make the area attractive to evening consumers. The arcade provided Atlanta its first taste of an enclosed plaza offering office space, shops, and services.

116

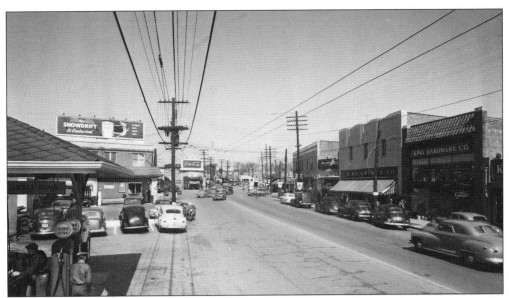

Buckhead, near the intersection of Peachtree and Roswell Roads, appears here, c. 1950. The once-rural community—named for a stag's head hung as a trophy on a pole—was annexed to the city in 1952, and is now Atlanta's premier shopping, entertainment, residential, and office district.

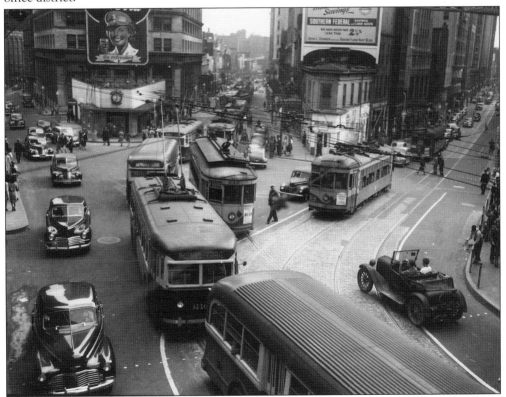

Shown here is Peachtree Street, near the present-day Margaret Mitchell Square, c. 1945. By 1949, these streetcars made their last run along Atlanta's streets.

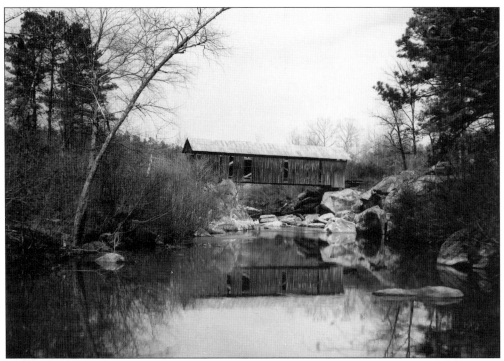

One of Georgia's last covered bridges is pictured here. At its peak, Georgia boasted 250 of these historic structures; only 13 remain today.

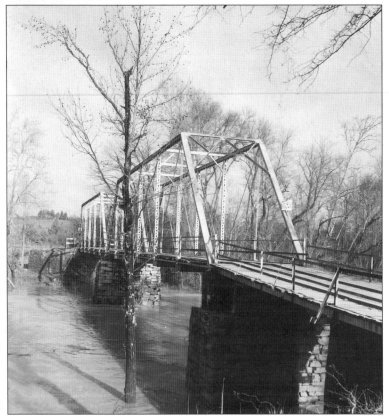

Often located on the same site as the old Chattahoochee River ferry crossings that gave many Atlanta streets their names, steel bridges like this one have been replaced by modern concrete structures. (Photograph by Guy Hayes.)

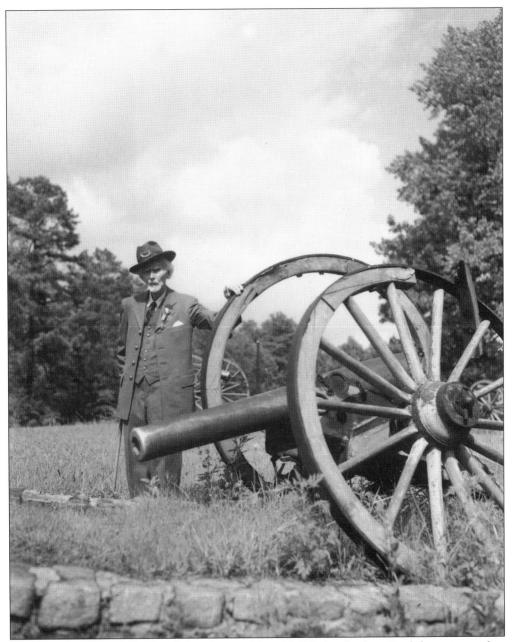

Henry T. Dowling, shown here when he was 98 years old, was the last Confederate general to reside in Atlanta's Confederate Soldier's Home.

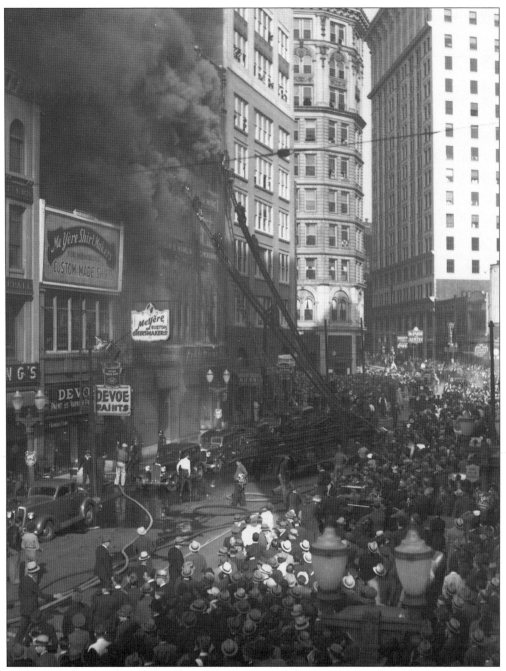

In November 1936, thousands of bystanders witnessed the destruction of the five-story home of the Cable Piano Company on Broad Street. A probe into the fire emphasized the city's need for more aerial ladders, masks, and equipment, but many were convinced that the "hysterical army" of spectators had caused much of the tragedy.

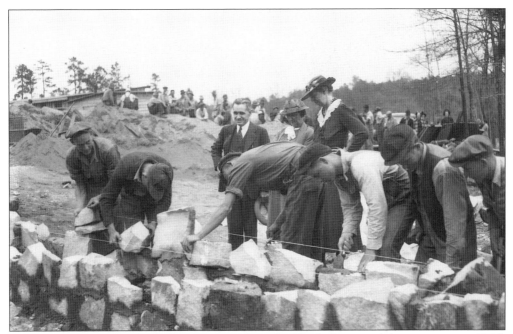

First Lady Eleanor Roosevelt observes crews from the Works Progress Administration, c. 1935. During the Great Depression, the government created agencies, such as the WPA, to provide work for the unemployed.

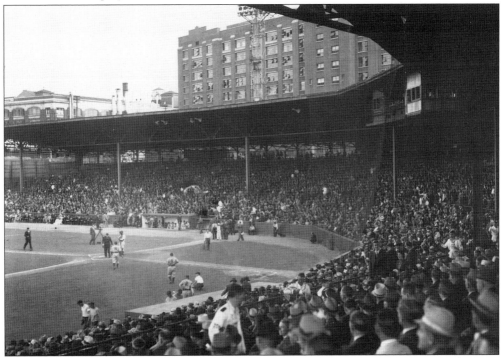

A crowd watches a game at R.J. Spiller Field, more commonly known as Ponce de Leon Ballpark, 1940. The park was home to the minor league Atlanta Crackers, and on occasion to the Atlanta Black Crackers, until the mid-1960s.

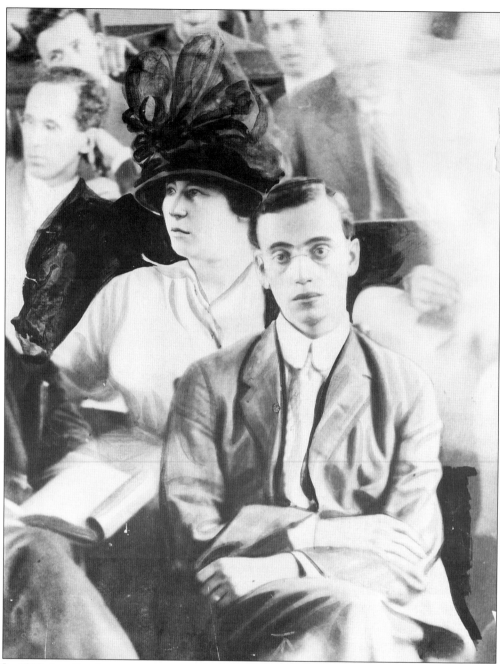

In 1913, Leo Frank, a prominent member of Atlanta's Jewish community and manager of the National Pencil Company, was charged with the murder of 13-year-old Mary Phagan, one of his employees. Amidst sensationalist press coverage tinged with anti-Semitism, Frank was found guilty and sentenced to death. After numerous appeals, Frank's sentence was commuted to life in prison, but vigilantes angry with the decision abducted Frank and lynched him in Phagan's hometown of Marietta, Georgia. These images show Leo Frank sitting in the courtroom during his trial (above) with his wife, Lucille Selig Frank; Leo Frank (opposite page, top); and Mary Phagan (opposite page, bottom), all *c.* 1913. Frank was posthumously pardoned in 1986.

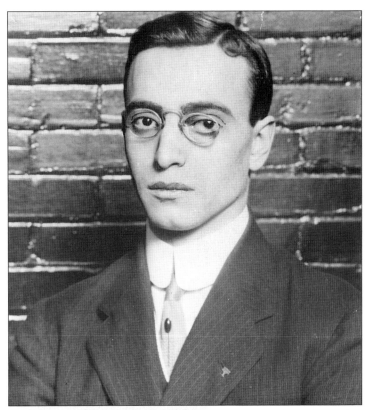

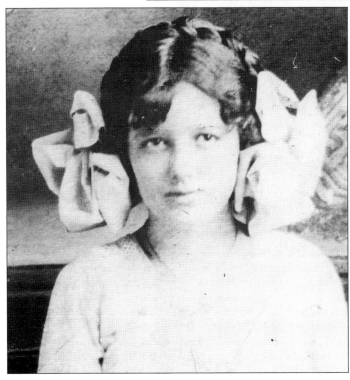

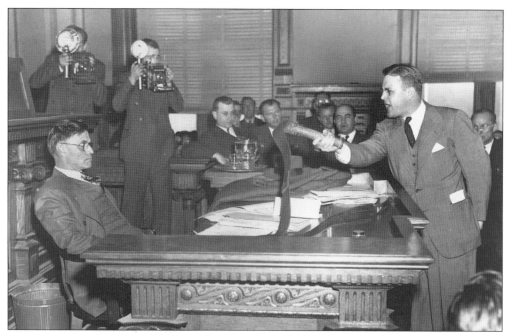

In an emotional moment, Fulton County prosecutor Dan Duke brandishes a bull whip at Governor Eugene Talmadge during a November 1941 clemency hearing for Ku Klux Klan members convicted of using the whip in 53 floggings. (Photograph by Guy Hayes.)

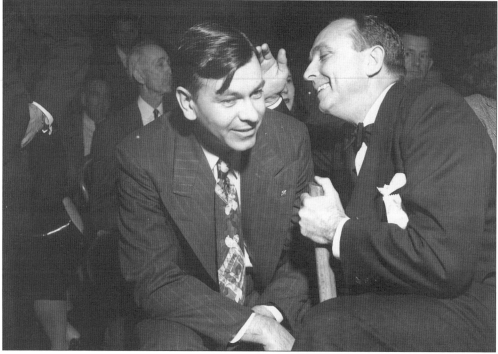

Two Georgia powerbrokers, Herman E. Talmadge and E.D. Rivers, speak confidentially during a Democratic convention. Both men served as Georgia's governor, and Talmadge went on to spend a quarter-century in the U.S. Senate.

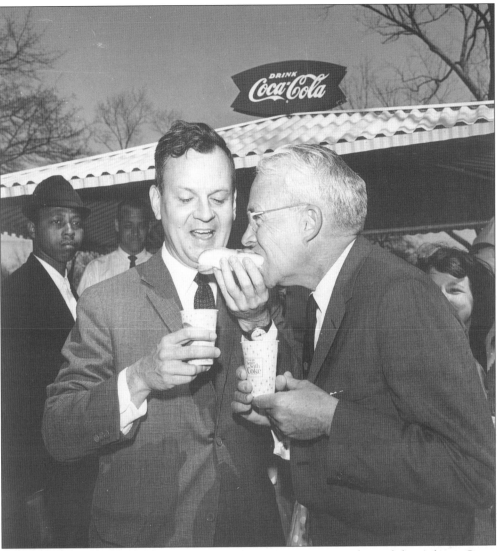

With a Coke, a smile, and a hot dog, Arthur Montgomery, president of the Atlanta Coca-Cola Bottling Company, and Ivan Allen Jr., mayor of Atlanta, celebrate groundbreaking at Atlanta-Fulton County Stadium, 1964. The two were driving forces in bringing professional baseball to Atlanta.

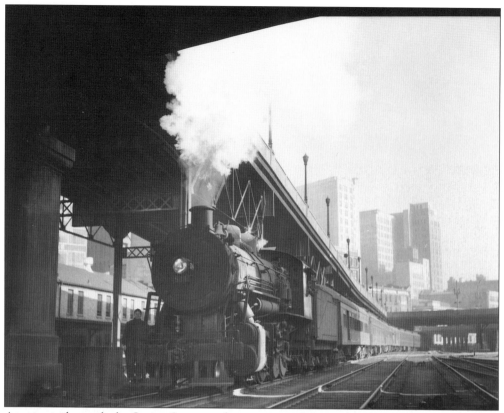

A train sits beneath the Spring Street viaduct as automobiles and pedestrians travel overhead, c. 1942. Atlanta's viaduct system began in 1921 to help relieve safety and traffic problems caused by downtown rail lines bisecting the city's business district.

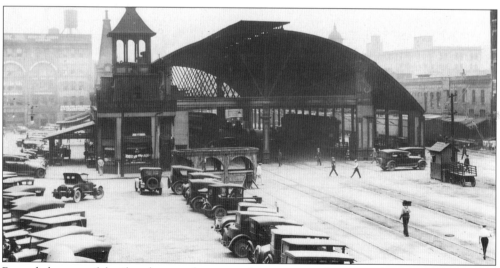

Regarded as one of the "handsomest, largest, and most commodious iron depots in the country," Atlanta's second Union Station was completed in 1870 on the site of its predecessor, which was destroyed by Sherman's army. It was razed and replaced by a new Union Depot in 1930.

His voice was tight. The rage had come to the surface, had threatened to burst into the open.

"All for nothing!" Mangin repeated through clenched teeth.

"There was never any point to it," Durand had said. "Don't you see, Charles? We should never have come."

A sound behind him broke his reverie, drawing him back from his memories. He turned to see that a second *tirailleur* had arrived to relieve the sentry. The two exchanged places with a stiff formality, and the relieved man disappeared into the fort. Durand took a last look around the torch-lit platform, then turned and made for the door. The sentry snapped to attention as he approached. He nodded absently as he passed and was at the door when the man spoke.

"Monsieur."

Durand stopped, turned to look at the soldier. His face was familiar. With a start Durand realized it was the same soldier whose rifle he'd knocked aside when the bearers were fleeing the road, all those months ago.

"What is it?" Durand asked.

"I am wanting to know a thing," the man said. Durand waited.

"Why does the white man Durand say we must go?" the soldier asked. "This white man brought us here. He made us fight, and many men suffered and died so that we might win this place. Why does the white man take us away now?"

Durand could think of nothing to say to this. He turned towards the door, but the man went on.

"If this white man takes us away from here, what do I say to the wives of the dead? To their sons and daughters? Why did they die for this white man?"

Durand hesitated at the threshold.

"This white man cannot say," he said, then plunged himself into the darkness of the fort.

Chapter 51

London, 30 January 1899

Over brandy, Lawrence offered Welles a job.

They had dined at Lawrence's invitation, in the same room of the Travellers Club where Welles had held the man at gunpoint five months before. He wondered if it was a coincidence, or if Lawrence had arranged it out of some macabre sense of humor. He had not wanted to come. He had no desire for Lawrence's company. Still, he had consented, if only out of curiosity, for he assumed the man had something to tell him. He had been right, it seemed, but he'd never have imagined it would be this.

They had passed dinner politely, if not warmly. Lawrence had surprised Welles with the good news that he was no longer a wanted man in France. The death of the forger Leeman — it had been decided — was some mystery of the underworld which the man frequented, and the case had been closed as unsolvable. As for Hull, the French authorities had been convinced to treat his death as a suicide. From that start, Lawrence had made every effort to be a congenial host and, despite Welles's obvious coolness, he now launched into a lengthy appreciation of Welles's talents and his suitability for a permanent position in the Foreign Office.

"You've acquitted yourself well in this affair," he said. "Especially when one considers the odds stacked against you,

Printed in the USA
CPSIA information can be obtained
at www.ICGtesting.com
LVHW072138260923
759443LV00031B/433

9 781957 185255